WILLIAM ALSOP
Buildings and Projects

Mel Gooding

To my sister Barbara and my friend William Chaitkin

Phaidon Press Ltd
140 Kensington Church Street
London W8 4BN

First published 1992

© 1992 Phaidon Press Limited

ISBN 0 7148 2766 5

A CIP catalogue record for this book is available
from the British Library

Printed and bound in Hong Kong

The photograph on page 9 is reproduced
with the permission of Stuart Smith.

CONTENTS

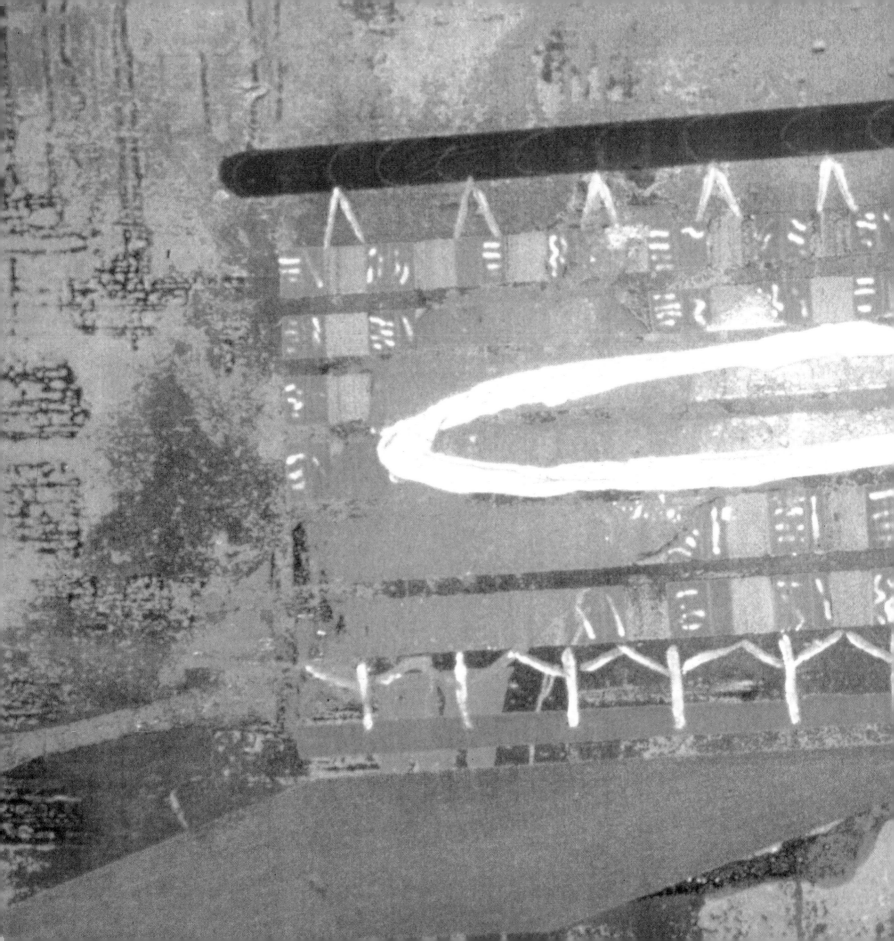

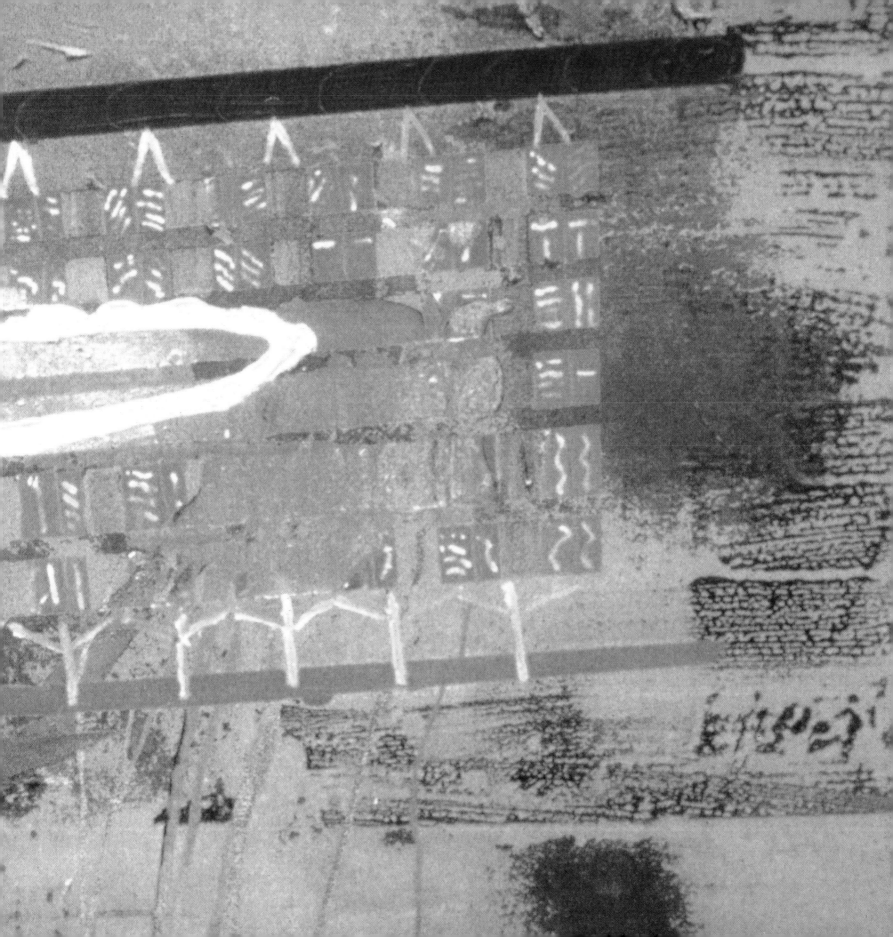

INTRODUCTION

Talking with Will Alsop over the years around tables in late night pubs and kitchens, at dinners, drinks and parties (funny how I associate him with pleasure, not work, with work as pleasure, with games [language] and visual play, using pleasure to make a work: dreams / projections / a thousand ideas with one or two good ones amongst them too) you get to understand what he means: an architecture can exist by allowing itself to be discovered, not taught. Alsop is open – to suggestion, to influence, to offers: he makes you laugh, he makes you think, he listens, he likes your ideas (he steals them and anything else he can lay his mind on). He imagines.

His architecture begins not in solving problems, but in inventing answers to questions you (and he) didn't know existed. Sometimes it's a good question, and when the problem comes along it's the beginning of a surprising solution (the obvious is often as surprising as the surprising).

Alsop's architecture is a place to live: (existentially as well as spatially) he imagines it from the inside out; he starts from within (his outsides make more sense when you know this). His windows are eyes for seeing out of, his floors for walking on, his rooms big and small conceived from their centre. Pleasure and diversity are the keys to the rooms (and to the cities) he dreams. If you are happy in this space, does it matter that it negates every architectural norm since the cave? (And the cave proved infinitely adaptable: shelter / parliament / cathedral / roofed city.) I've never heard Alsop speak of a project in terms of the building as seen; he talks as he conceives – of the articulation of spaces for activity and inactivity, movement and stillness, doing (to-ing and fro-ing and coming and going) and daydreaming.

Great architecture anticipates (it is actually in practice, of course, an art of premeditations and predictions); and the architect doesn't always know what it is that is anticipated. He imagines what might be possible; what he cannot predict is the uses to which his buildings and places might be put as a consequence of forms of behaviour as yet unknown. Alsop's procedures and techniques are deliberately intended to deprogramme and dissolve what is known and recognized, to discover the surprising and the unexpected.

Purpose and pleasure are not in conflict in his lucid imaginings. Conversation and reverie are his modes of enquiry; play (of the mind / of the spirit) a manner of proceeding; extrapolation and projection the stuff of his realizations. Alsop is no theorist. His philosophy is provisional and non-prescriptive; the evolving and dynamic outcome of creative collaborations and actual problem solving. The humane practicality of his vision is celebrated by this book and is being demonstrated at last in the real contexts of Hamburg, Bremen, Cardiff, Marseille and Bordeaux.

previous page: Alsop's study painting for the Hotel du Département, Marseille.

MEL GOODING Barnes, April 1992

HÉROUVILLE,
SAINT-CLAIR
Tower Project

The Tower Project for Hérouville Saint-Clair was conceived as a collaboration on a single site between a group of European architects: William Alsop from the UK, Massimiliano Fuksas from Italy, Jean Nouvel from France and Otto Steidle from Germany. The scheme was to encompass a hotel, offices and housing, with a ground-level shopping centre to be designed by Alsop. The structure – a space-age crustacean inspired by his son's Manta Ray spaceship – was to act as a bridge across the road and included an aviary through which the public could walk while shopping.

SECTION

NORTH ELEVATION

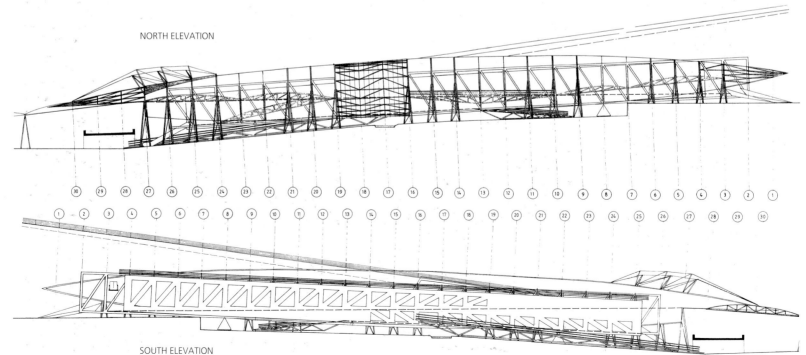

SOUTH ELEVATION

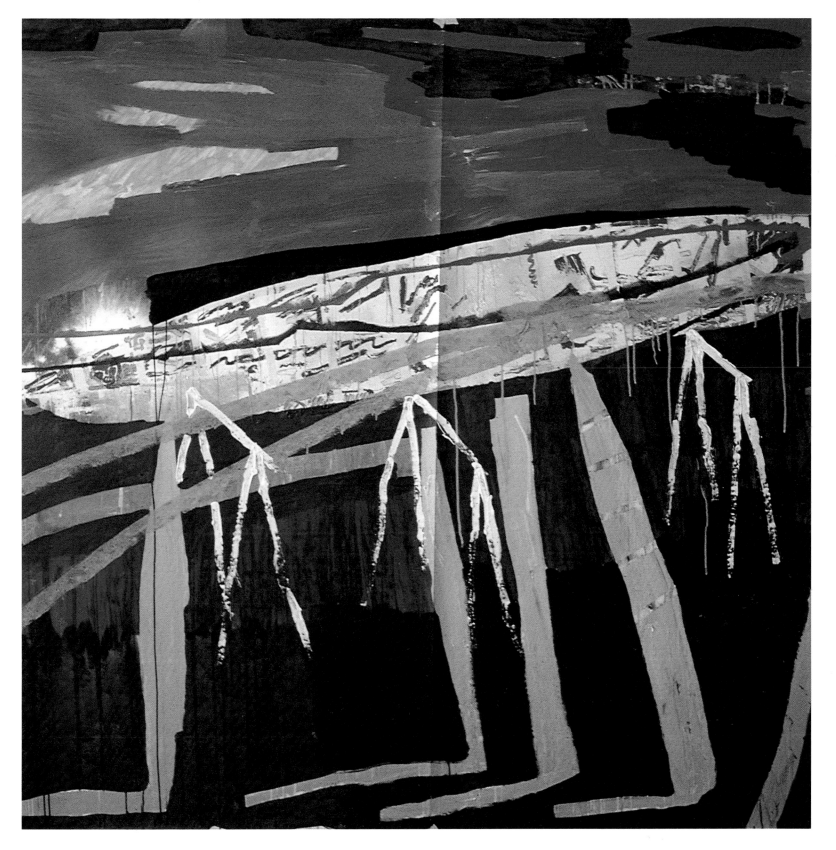

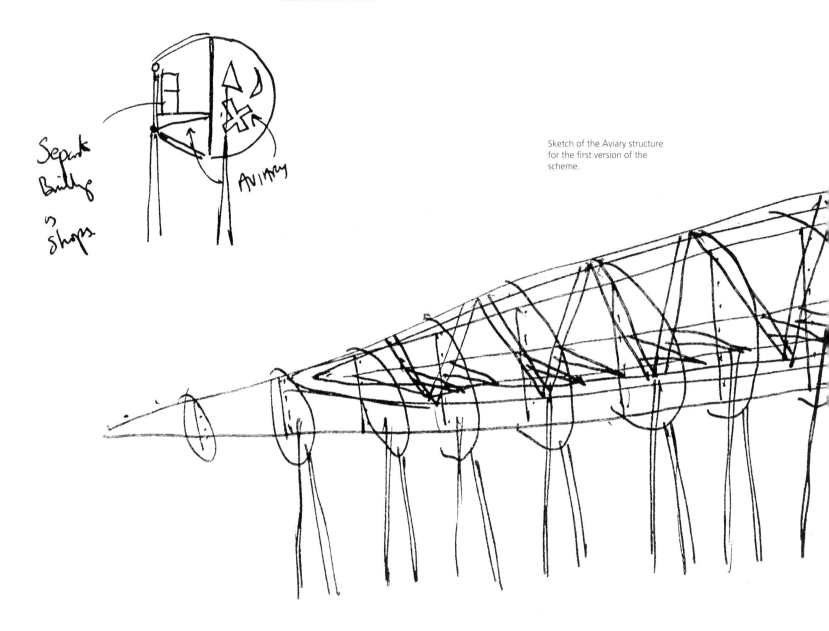

Sketch of the Aviary structure for the first version of the scheme.

The plans for the project changed in 1989, with the result that the shopping centre was expanded onto an adjacent site and the tower was abandoned.
The final design is for a structure comprising the simple repetition of steel ribs supported at one end on A-frames and at the other from a concrete spine, with the whole body covered in sheets of zinc which overlap like the hide of an armadillo. The central spine is glazed, allowing daylight to penetrate deep into the building. The interior is organized around the structure, with one shopping level in the ribs and another under the beast's belly at street level.

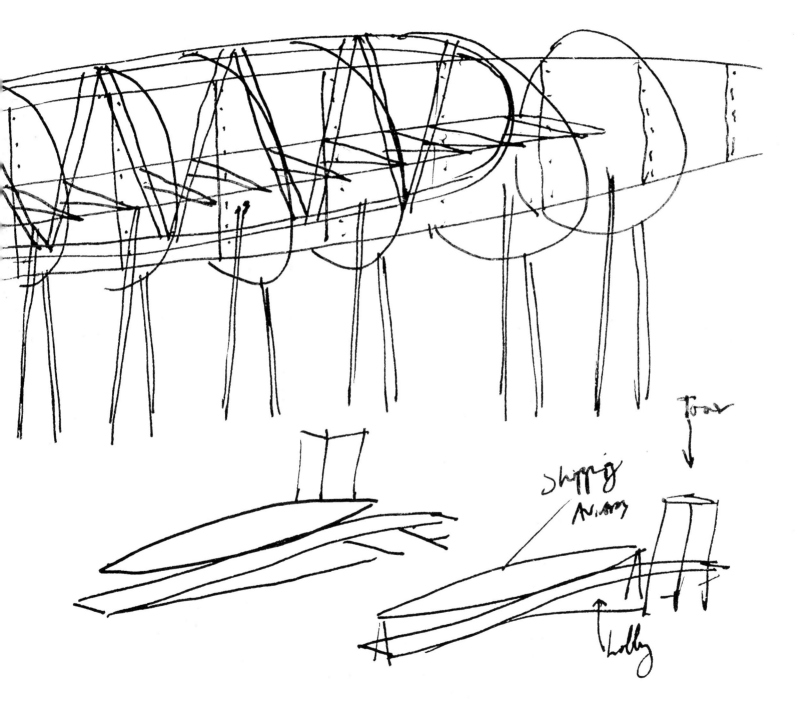

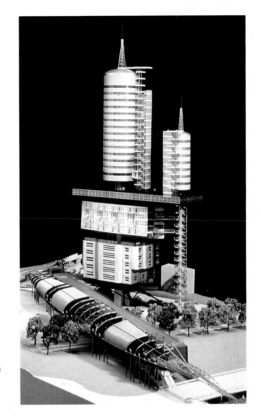

The completed model;
proposals from top to bottom
by Jean Nouvel, Otto Steidle,
M. Fuksas and William Alsop
along the ground.

Cross section through the
shopping centre for the
second version of the scheme.

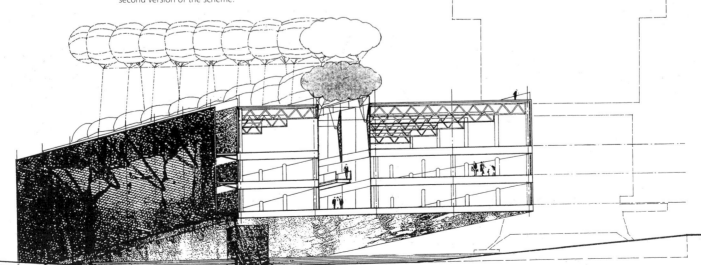

16

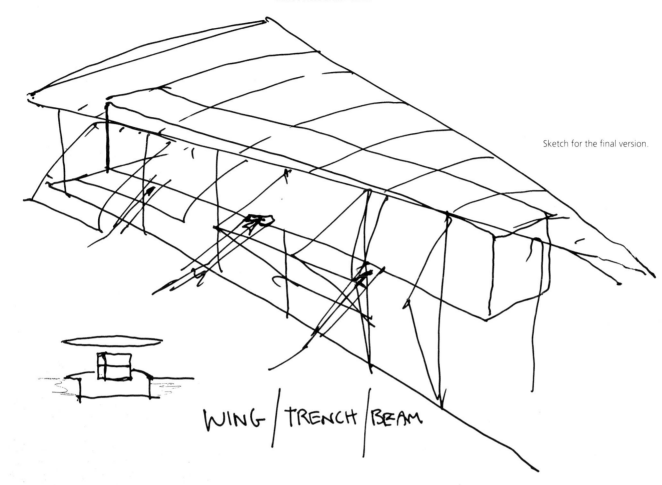

Sketch for the final version.

WING / TRENCH / BEAM

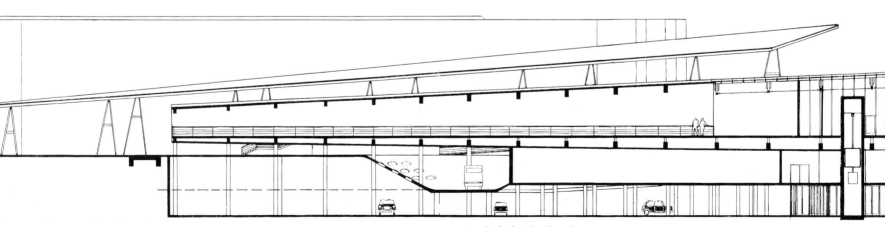

Longitudinal section through
the shopping centre from the
final scheme.

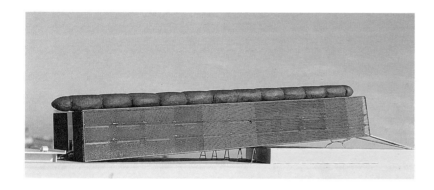

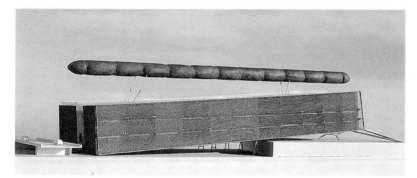

Model of the second version
of the scheme.

Sketch and painting of the
final version.

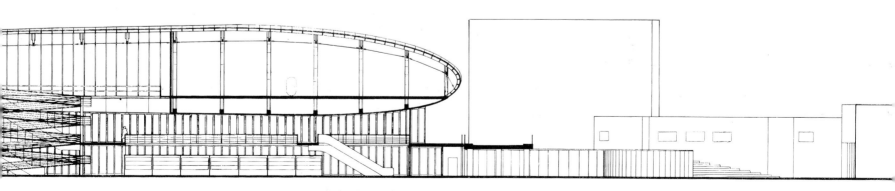

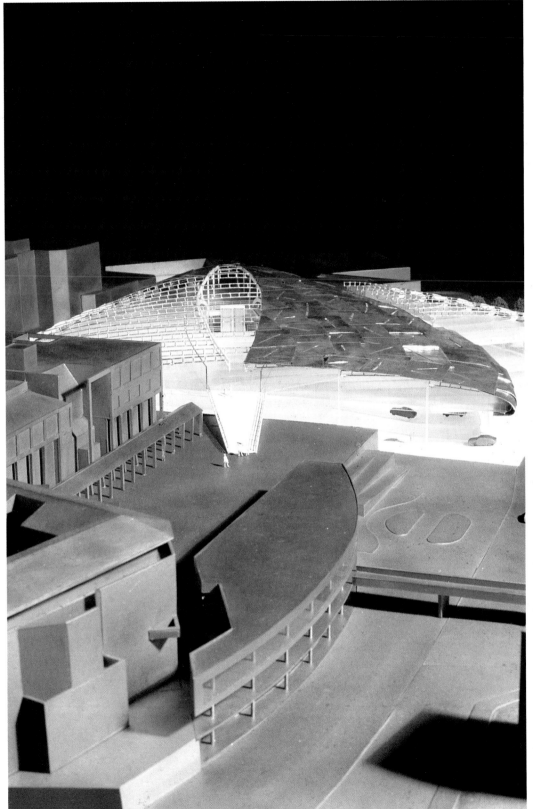

Final version of the scheme;
presentation model and
perspective drawing.

Trilobite fossil.

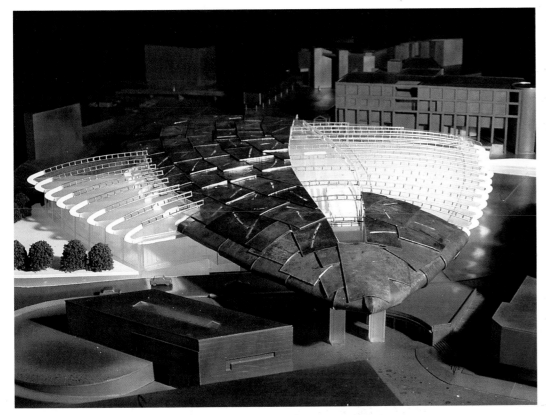

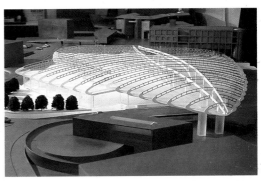

Model of the final version,
part clad and unclad,
showing structural ribs.

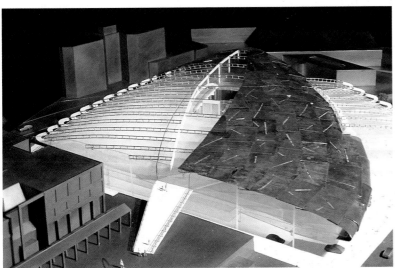

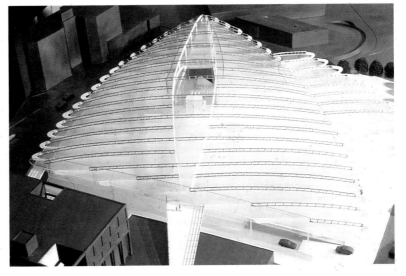

BEHAVIOUR

As against the description of buildings in terms of their function, Alsop persistently refers to the behaviour of people within them. And around and between them. To the Modernist dictum 'Form follows function' he opposes 'Function follows behaviour'. 'Whether there is a "form" at the end of it is open to question.'

The familiar catalogue of building types (the house / the hospital / the school / the pub) implicitly defines people's behaviour as a function of the building that is explicitly created for it. But do people conform to those behavioural paradigms? Are people in hospital only ill, or caring for the sick? And what does being ill mean in terms of behaviour? (It modifies performance, certainly.)

Isn't what is wrong with hospitals is that their forms follow narrow (inaccurate / inappropriate) notions of function, and fail to take account of the multifarious realities of behaviour? 'Knowing', as a given, the building's function, the architect consults Neufert, becomes au fait with current thinking, determines specifications, and what is left in the design of a hospital is merely a choice of forms and materials, and of their configurations within known constraints.

But begin with behaviour (various / unpredictable / changing / complex / layered / ambiguous) seeking many ends: pleasure / comfort / well-being / friendship; play; knowledge; profit. And then consider the requirements of those in hospital for the pursuit of varieties of behaviour: privacy; company; mobility; means of access to the world at large. In this way you might build up a different picture, a different brief altogether, unconstrained by a one-dimensional functional concept of the building. Surely in the conventional hospital these things are provided for – the games room; the curtains round the bed; the television room; the covered walkway? 'Yes, but if you followed through this idea of provision for real behaviour, you might not build a "hospital" at all: your strategy would be different, looking to ways of mobilizing medical facilities to meet actual modes of behaviour. You might design on the model of terraced streets of houses, with kitchens, sitting rooms and bedrooms, domestic rooms to be private in, to rest in, to get better in. Houses with small gardens, and streets with pubs and shops.'

Why build hospitals on the model of institutions of concentration (the closed place where the sick are kept together, in segregation; the Bethlehem; the prison)? And what are the behavioural implications of those models? Bedlams drive people mad; prisons create criminals; hospitals make you feel ill.

Consider the Mortlake Palace of Arts (nb: the Palace of Arts, not Art Gallery, not Arts Centre): 'the grain silo was an empty box pregnant with opportunity. It had never been created as a space for people: emptied of its cylinders it was to be converted into a space for unspecified behaviour.' By projecting a situation in

which the physical space could be dynamically modified, temperature could be controlled, lighting could be controlled (all the things an architect can do), Alsop and his colleagues on the project set out to create an indeterminate space. 'If you could do that with every commission, you could forget the list of building types and create buildings that might be infinitely adaptable, structured spaces that could be turned to any purpose, and even lead to the invention of new forms of behaviour, new purposes.' The Palace of Arts in Mortlake would not have conformed to any known expectation; it would open up possibilities. New behaviour would create new art forms: that was its purpose.

Alsop acknowledges the antecedence of these ideas in Russian Constructivism, which had to conceive new building types and create spaces for activities that had not existed before; to make buildings that would accommodate new behaviour. (Not Tatlin's Tower: in that project, form followed function indeed, and incorporated metaphor. Alsop is not interested in metaphor.)

Consider this: a Line in Bordeaux, which performs no predetermined function (it is entitled 'A Cathedral or Disco'). It constitutes a short cut across the river – which is, and is not, its raison d'être. Other functions may follow as people use it for that purpose. But they need not be specified in advance. (In reality, they usually have to be.)

Alsop is creating arenas for behaviour.

Antecedents: Piazza del Campo in Siena: a civic square; a meeting place; the race track of the Palio. Piazza del Duomo, San Gimignano: a setting for a conversazione; an arcaded ambulatory; a market-place; an open air theatre; a site for civic ceremony; a place for alfresco eating and drinking. The seaside pier: a projection, a focus; a means to a view of the front; a peninsular promenade; a platform for fishing; a magic limbo for performance; a base for a fair. All are places for watching people.

'These are places for wonderful experience, open spaces and enclosures, with changes of level, steps and raised stages; theatres for living. And those indeterminate spaces in buildings whose purposes are discovered through the behaviour of those who use them will be places that do not determine how you behave, but leave open infinite possibilities of performance. Buildings which are to contain such spaces must be extraordinary events in themselves, visually exciting, spiritually enlivening, open to many interpretations.'

Like the piazza, the table top is an empty space; a plane of social discourse. How it is used is determined by the relationships of those around it, and what they do at it. Rather than a building being a vessel to contain known behaviour, the behaviour might determine the building, for a minute, a day, a week, for as long as is needed.

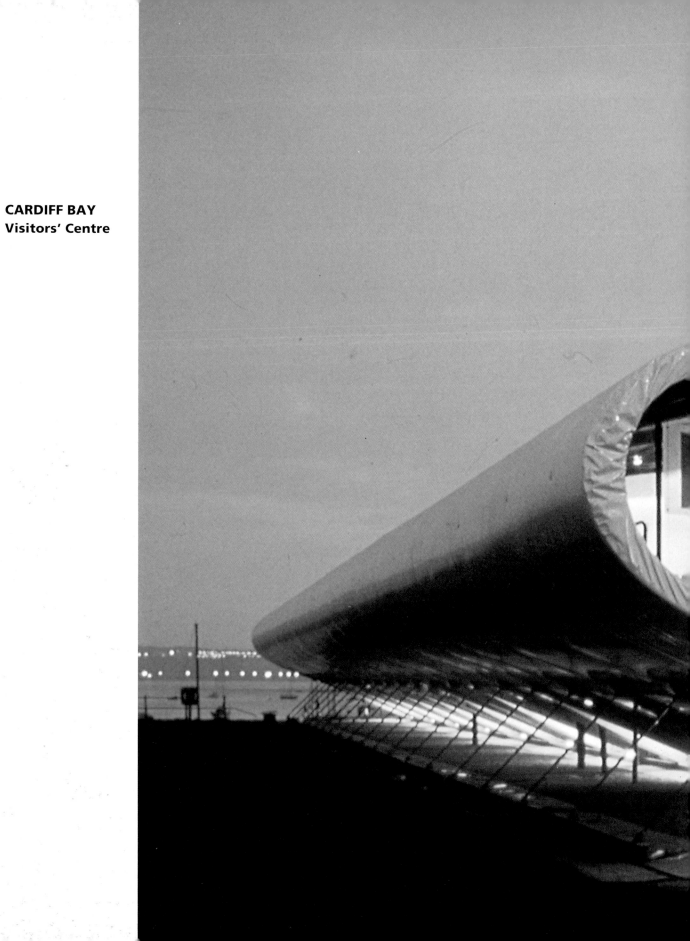

CARDIFF BAY
Visitors' Centre

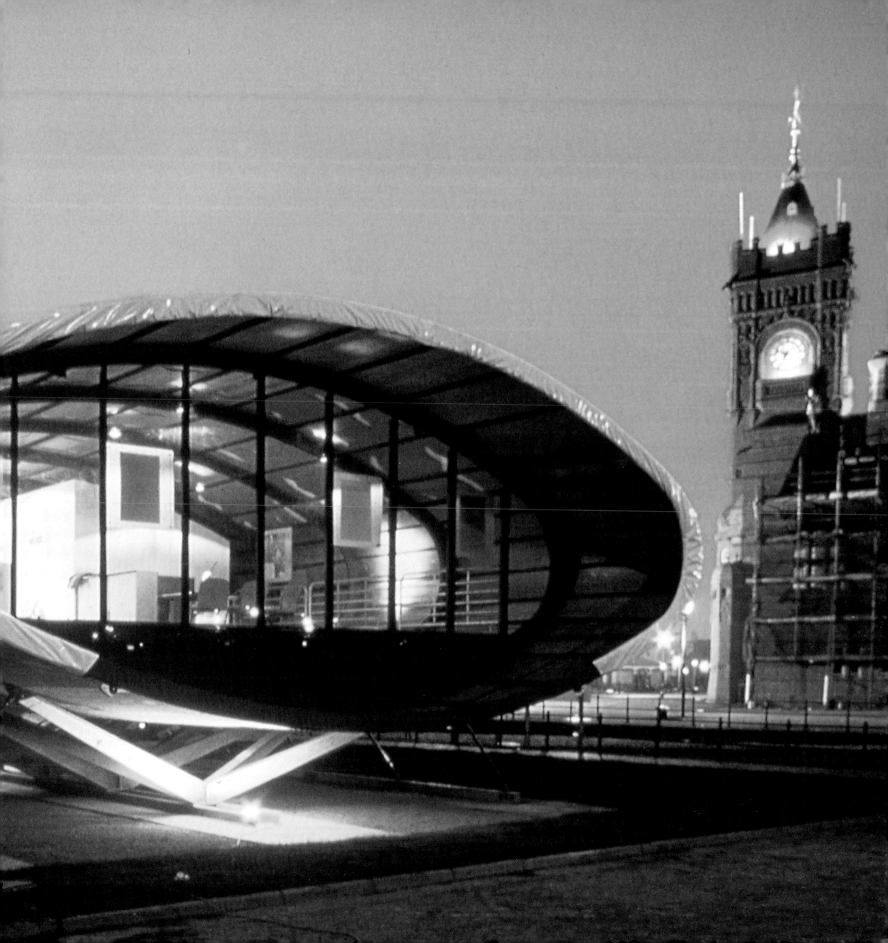

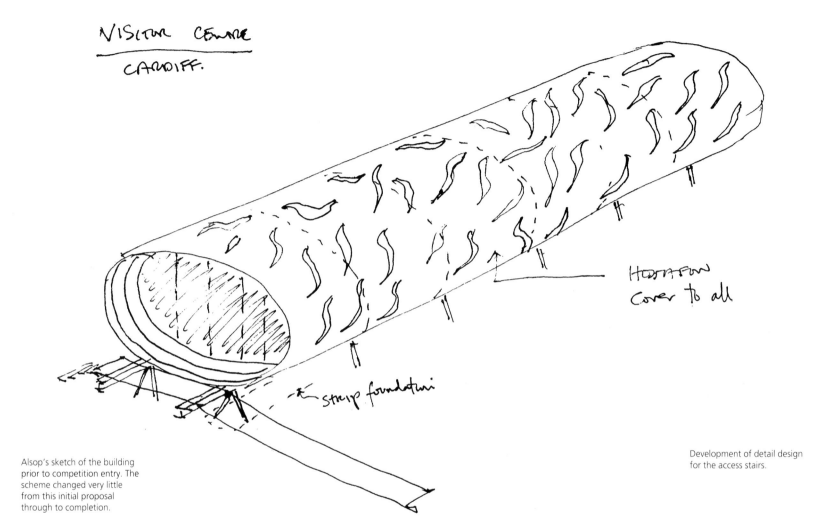

VISITOR CENTRE

CARDIFF.

Horizon Cover to all

strip foundation

Alsop's sketch of the building prior to competition entry. The scheme changed very little from this initial proposal through to completion.

Development of detail design for the access stairs.

The Cardiff Bay Visitors' Centre is a low-cost, low-tech, temporary structure. Granted just two years' planning permission, its function is to house a series of exhibitions explaining the plans of the Cardiff Bay Development Corporation, including the Cardiff Bay Barrage. From the outside, the centre appears as an uninterrupted flattened tube, an effect achieved beneath the surface through the combination of a number of interlocking elements. Oval steel ribs supporting marine plywood panels form the basic structure, which rests on galvanized steel brackets attached to track-like steel foundations. The whole roll is covered in a weatherproof fabric skin, secured underneath like the flysheet of a tent and glazed at both ends. The interior is dappled by light diffused through the decorative abstract shapes cut out of the plywood panelling.

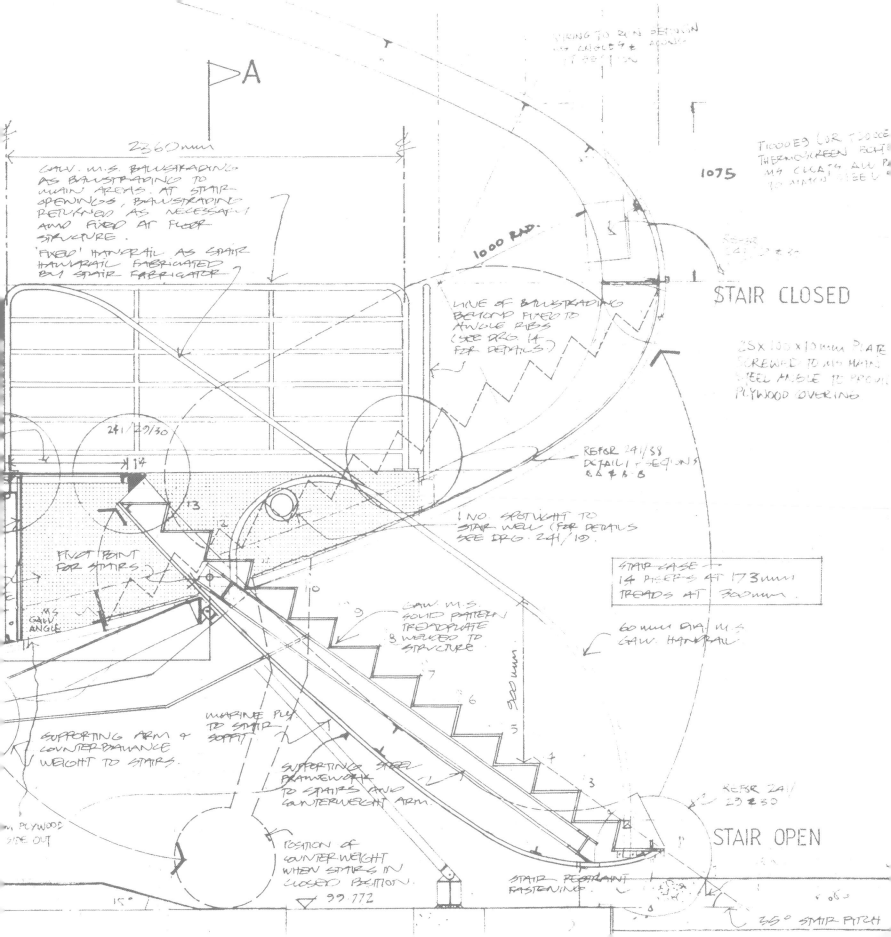

A

2360mm

GALV. M.S. BALUSTRADING
AS BALUSTRADING TO
MAIN AREAS. AT STAIR
OPENINGS, BALUSTRADING
RETURNED AS NECESSARY
AND FIXED AT FLOOR
STRUCTURE.

'FIXED' HANDRAIL AS STAIR
HANDRAIL FABRICATED
BY STAIR FABRICATOR

1000 RAD.

1075

LINE OF BALUSTRADING
BEYOND FIXED TO
ANGLE RIBS
(SEE DRG. 14
FOR DETAILS)

STAIR CLOSED

25 x 100 x 10mm PLATE
SCREWED TO MS MAIN
STEEL ANGLE TO PROVIDE
PLYWOOD COVERING

241/29/30

14

13

REFER 241/38
DETAIL 1 + SECTIONS
A & A + B - B

PIVOT POINT
FOR STAIRS

MS
GALV
ANGLE

12

11

1 NO. SPOTLIGHT TO
STAIR WELL (FOR DETAILS
SEE DRG. 241/10.

10

9

GALV. M.S.
SOLID PATTERN
TREADPLATE
WELDED TO
STRUCTURE

STAIRCASE
14 RISERS AT 173mm
TREADS AT 300mm

60mm DIA. M.S.
GALV. HANDRAIL

8

7

6

5

900 mm

MARINE PLY
TO STAIR
SOFFIT

SUPPORTING ARM +
COUNTERBALANCE
WEIGHT TO STAIRS.

SUPPORTING STEEL
FRAMEWORK
TO STAIRS AND
COUNTERWEIGHT ARM.

4

3

REFER 241/
29 & 30

STAIR OPEN

PLYWOOD
SIDE OUT

POSITION OF
COUNTERWEIGHT
WHEN STAIRS IN
CLOSED POSITION.
99.772

15°

STAIR RESTRAINT
FASTENING.

35° STAIR PITCH

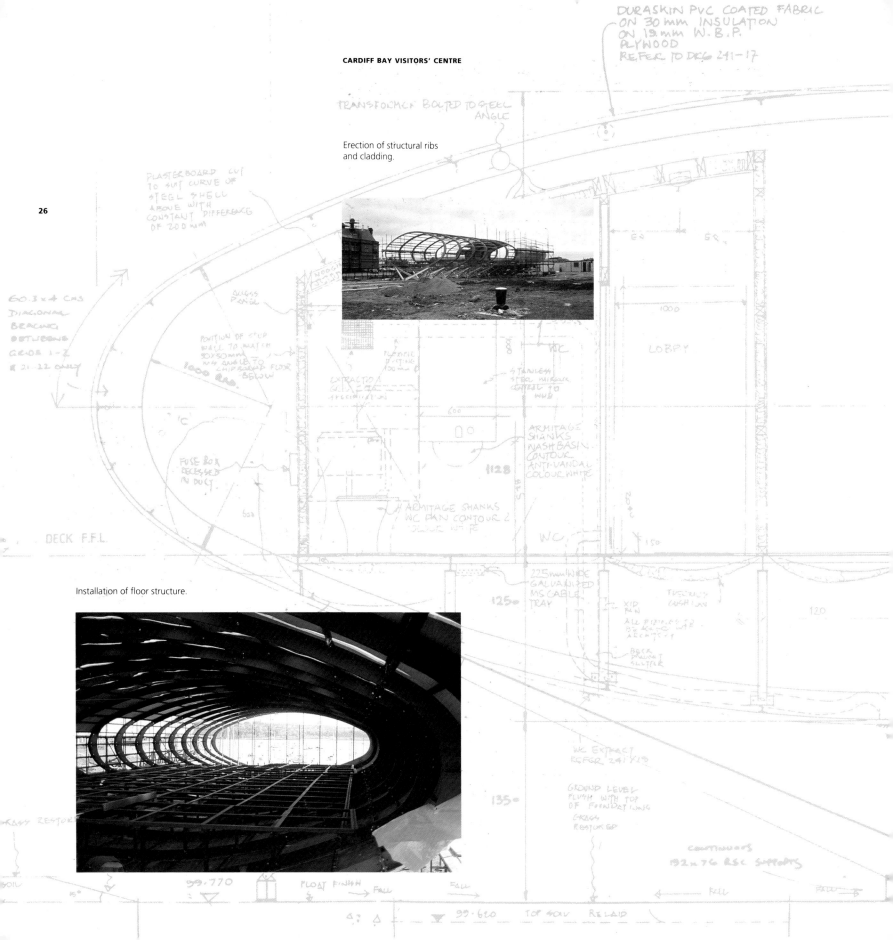

DURASKIN PVC COATED FABRIC
ON 30 mm INSULATION
ON 19 mm W.B.P.
PLYWOOD
REFER TO DRG 241-17

TRANSFORMER BOLTED TO STEEL ANGLE

Erection of structural ribs
and cladding.

PLASTERBOARD CUT
TO SUIT CURVE OF
STEEL SHELL
ABOVE WITH
CONSTANT DIFFERENCE
OF 200 mm

ACCESS PANEL

60.3 × 4 CHS
DIAGONAL
BRACING
BETWEEN
GRIDS 1–2
& 21–22 ONLY

POSITION OF STUD
WALL TO MATCH
50×50mm
M.S. ANGLE TO
CHIPBOARD FLOOR
BELOW

1000 RAD

NOGGIN

FLEXIBLE DUCTING 130mm Ø

EXTRACTION GRILL – TO SPECIFICATION

STANLESS STEEL MIRROR GLUED TO WWD

WC

LOBBY

1000

600

1128

ARMITAGE SHANKS WASH BASIN CONTOUR ANTI-VANDAL COLOUR WHITE

'C'

FUSE BOX RECESSED IN DUCT

ARMITAGE SHANKS WC PAN CONTOUR 2 COLOUR WHITE

DECK F.F.L.

WC

150

Installation of floor structure.

225mm WIDE GALVANIZED M.S CABLE TRAY

XPD RUN

TRICKLE CUSHION

ALL PIPINGS TO BE KEPT OUT ARCHITECT

120

1250

BACK PAINTED SHUTTER

WC EXTRACT REFER 241/18

GROUND LEVEL FLUSH WITH TOP OF FOUNDATIONS

1350

GRASS RESTORED

GRASS RESTORED

99.770

FLOAT FINISH

FALL

FALL

FALL

FALL

99.620

TOP SOIL RELAID

CONTINUOUS 192 × 76 RSC SUPPORTS

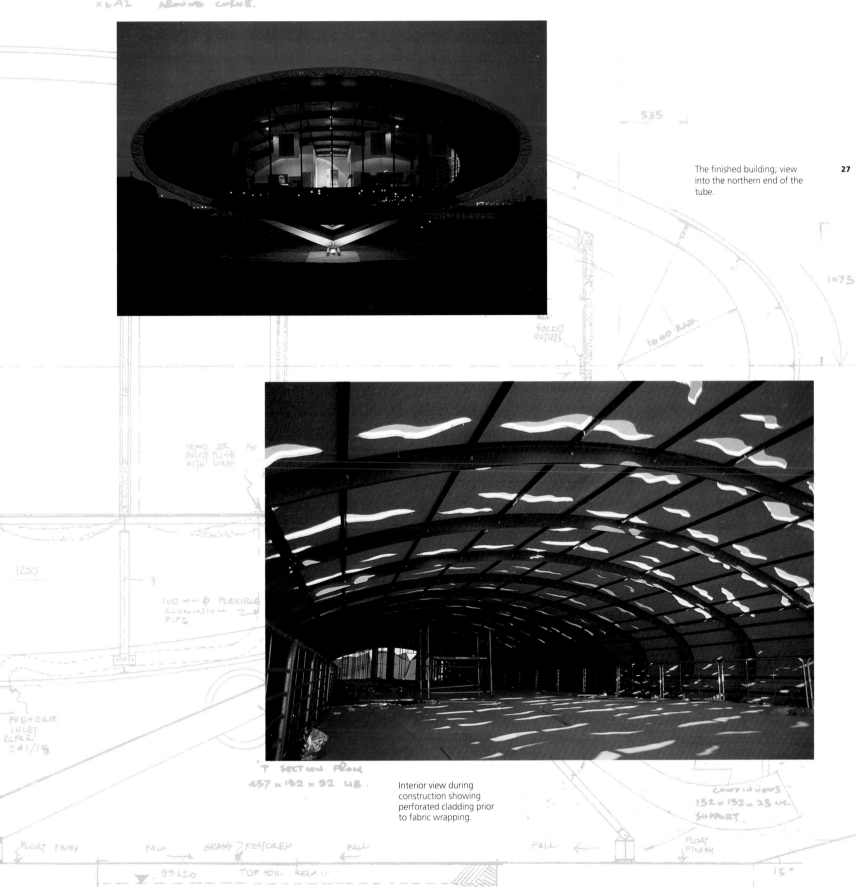

The finished building; view into the northern end of the tube.

Interior view during construction showing perforated cladding prior to fabric wrapping.

STYLE AND FASHION

Office motto: NO STYLE / NO BEAUTY

Alsop will not be guided by any notion of style, or any received notion of beauty. In which style should we build? Hübsch's great question which hovers over the perennial 'great debate', doesn't arise in his practice.

'What I do has style and beauty: so I don't rule those things out. If you start thinking in terms of style, placing yourself in a camp – Modernism; post-Modernism; late-Modernism; Deconstructivism; Rationalism; neo-Rationalism etc. – it's like choosing a suit of clothes and wearing it all the time. Why be limited by artificial constraints?'

Of course, the term style has a historical usage in the discourse of architecture, relating to what is technologically possible in terms of structure at a given time, and to the forms which technology creates and taste determines. Taste follows technology; and in this respect style is a function of technology; what is recognizable. Gothic style was impossible for pre-medieval builders.

(Boullée's drawings for Newton's Monument are the first to project a building beyond the technological capacity of its time: unconstrained by technological feasibility, it therefore went beyond the limits of style.)

What was good about Modernism was that it had a sound social strategy behind it: it supposed the primacy of the user's experience. Buildings should be light, white, simple, clean: in this it was a true style, a function of modern technology, its visual aspect subordinate to its purpose. Modernist architecture is given life by the behaviour of those who use it. (Hence its pleasing plainness.) The eclectic diversity of current 'styles', visual mannerisms adopted for the outsides of buildings that are identical within, is at the opposite extreme: façadism; nb Philip Johnson boasted at the RIBA that he had twelve big towers under construction, all in different styles, thinking that this indicated a new 'architectural freedom'. Not at all. It signals a constraint architects could do without: the client's freedom to pick a style to clothe a building regardless of technological possibility. In this way architecture is reduced to image-making, to a game of surface stylistics.

Alsop is, of course, concerned with the image of a building, with how it looks though that comes as a component of its total effect; of how it is experienced. A building has to be attractive to its users, not only in its interiors but in its aspects, seen on approach; it has to be a stimulating experience for those who live opposite or pass by. The anonymous minimalism of much Modernist architecture lacks this stimulus to the passer-by, and its forms and materials are sometimes obtrusive and irritating (it makes us irritable); buildings should have presence, of the right kind.

Why is it such a fantastic experience to stand in Venice's Piazza san Marco or Siena's Piazza del Campo? Because the weight and presence of the buildings in such great ensembles make for a unity of effect and of atmosphere that is undistracting to conversation: such architecture encourages civilized behaviour.

We accumulate memories of buildings and these play their part in the way we look at and think about architecture. Pure anonymity isn't enough; in every building there is an element of recall.

Alsop remembers:

living as a child next door but one to Peter Behrens' house,

the first Modern Movement house in England

tobogganing by a water tower

the Saxon tower at Earl's Barton

the Newport Transporter Bridge

photographs of Erskine's house on Liso

and so on.

'By making a building you are contributing to people's lives; pure anonymity isn't enough: how a building looks (its image) is one of the means by which people locate themselves on the surface of the earth. Recognizing that is one of the responsibilities of the architect.'

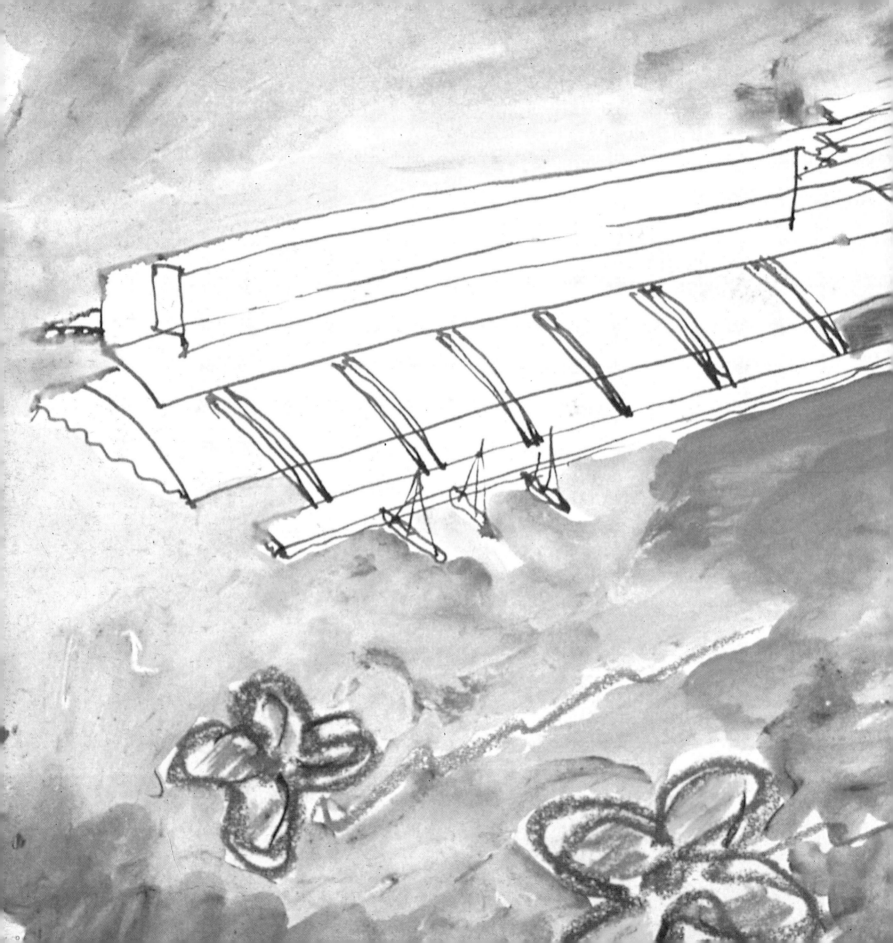

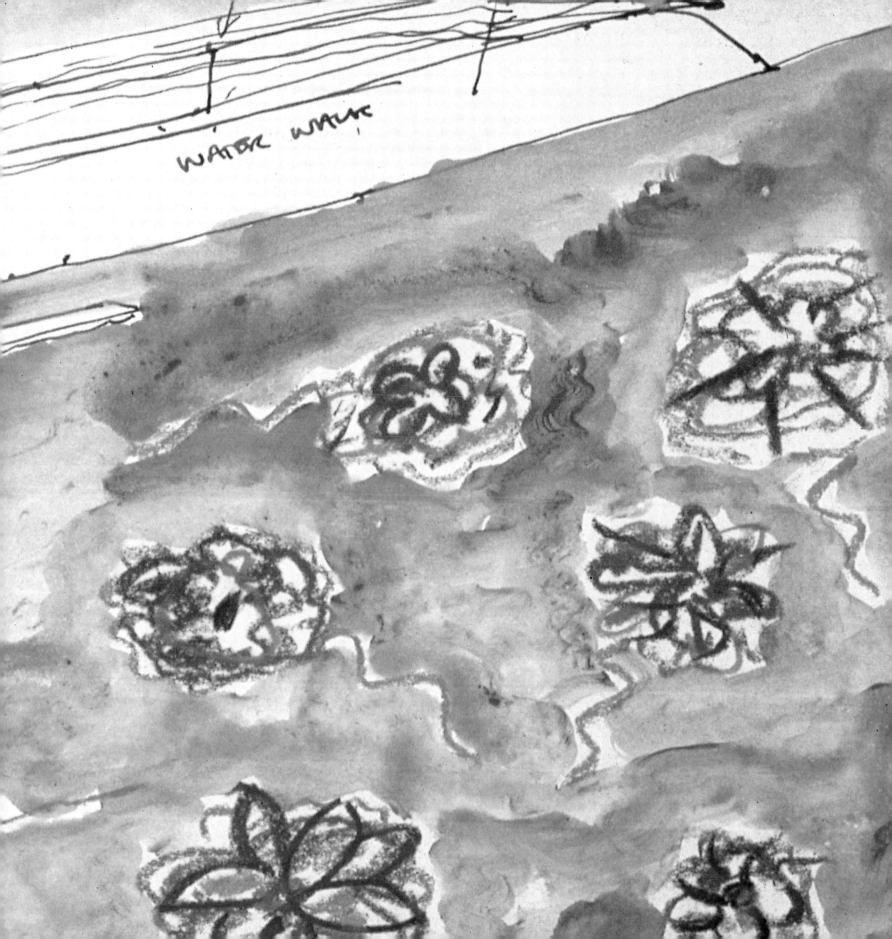

In dreams begin responsibilities. (Yeats)

Weight and presence come about because buildings embody cultural, spiritual and philosophical experience: the transcendental light of the High Gothic is not found in nineteenth century Gothic interiors (those have their own, Victorian, qualities of light and colour, and grand they might be). Façadisms and neo-isms are merely aspects of fashion; it is in the nature of fashions to go out of vogue, to become 'old-fashioned'. The great buildings, and their combinations in great streets, squares, towns, cities, never go out of vogue. The great historical styles in their local manifestations define time and place in forms and spaces for as long as they survive. Realizations of spirit, passion and intellect constrained by social need, they shape and give meaning to our experience of the world. Alsop quotes Schiller: 'Mankind has lost its dignity, but art has recovered it and conserved it in significant stones.'

Distinguishing between image and style, in its lesser meaning, Alsop shows no concern for 'recognizability': he has no interest in a distinctive 'look'. He is envious of the coherence of the shared ideology of the great Modernists, a shared set of spiritual objectives and social ideas: their shared agenda.

NO STYLE – but that which emerges, unpremeditated, unforeseen.

NO BEAUTY – but that which is seen in the course of the work, the painting, the design, and its outcomes.

Being what?
Not something that can be advocated.

previous page: Alsop's water-colour sketch for the River Garonne 'Activator' Bordeaux.

Le Corbusier: 'The Architect, by his arrangement of forms, realizes an order which is a pure creation of his spirit; by forms and shapes he affects our senses to an acute degree and provokes plastic emotions; by the relationships which he creates he wakes profound echoes in us, he gives us the measure of an order which we feel to be in accordance with that of our world, he determines the various movements of our heart and of our understanding; it is then that we experience the sense of beauty.'

Where is beauty to be found? In beauty spots: places not designed to be such, but found to be. (They reflect taste.)

What do such places have in common? The combination of simple things (blueness / water / greenness / space / objects) experienced in a good light. Places are perceived as beautiful where experience is pleasurable. Behaviour defines the beautiful. Behaviour is complex; a response to the complex experience of a multiplicity of minute particulars. (Remember Wittgenstein lowering a ceiling by a centimetre.)

Alsop: 'If you set out to design a "beautiful" building you have to fall back on what you know already. In that way, you could design a "beautiful" Georgian building…'. (You are working with a received aesthetic: pastiche Georgianism appropriates that and uses it as a programme for the outside of the building.) '…or a beautiful Modernist building.' (There is a plenitude of prescriptions.) 'But you cannot set out to make beautiful something not seen or imagined before: it must bring its beauty with it, a quality to be discovered.'

Our sense of beauty derives from our total experience of the world and from the penetration of that world by art in all its forms. Alsop's architectural aesthetic is shaped by movies, photography, painting, poetry, novels, swimming, imagining claustrophobia, talking, drinking, dreaming, and so on. (Of course.)

**CANARY WHARF
Lifting Bridges
and
Control Building**

The commission for a pair of lifting bridges at the eastern point of entry to Canary Wharf included the overall architectural direction of the development and design input into the embankment, roadspans, lighting and landscaping as well as the bridge structures and control building. The bridge design was determined by the decision to make visible the working parts of the counterweight system: the great A-frames, pivots and hydraulic rams supporting the 25-metre spans. This necessitated the construction of a separate building to house the hydraulic plant, which in turn supports a control cabin dramatically cantilevered up and away from it for maximum visibility. The control building is of steel frame and steel plate construction, painted silver. Every penetration, protrusion and angle is exaggerated to maximum sculptural effect.

The Control Building with
its projecting cabin.

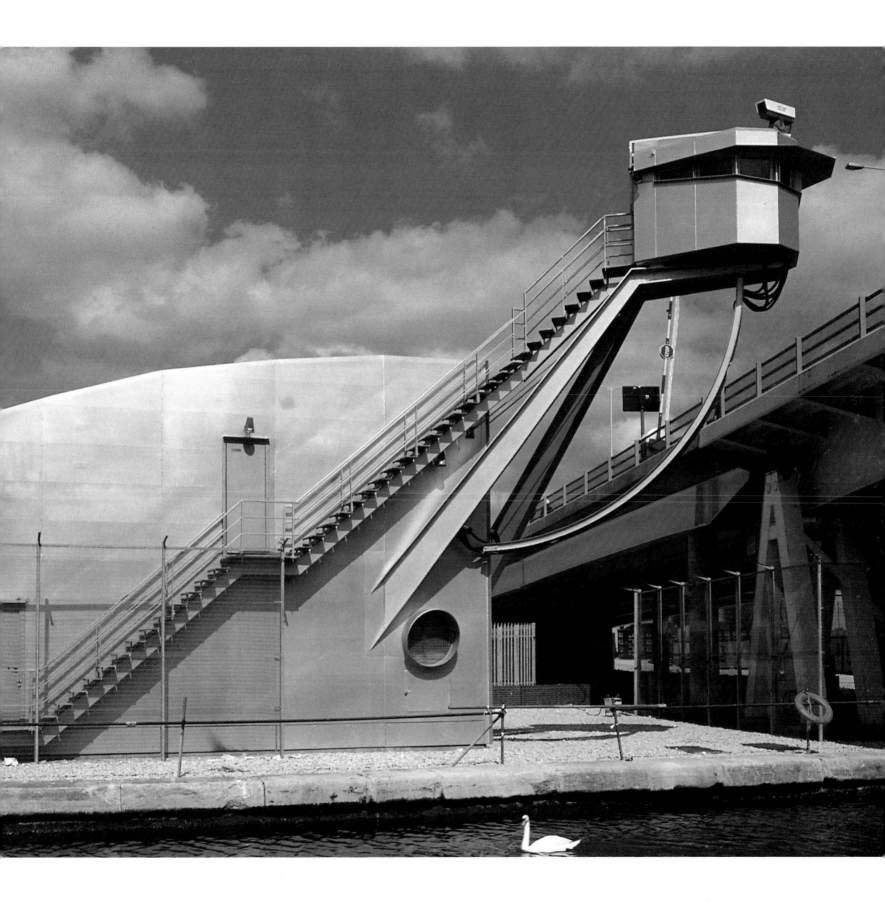

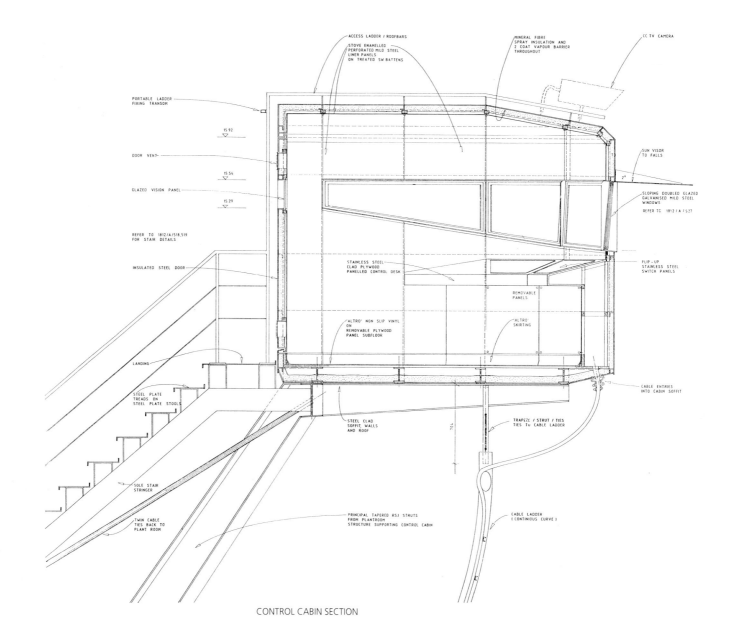

ACCESS LADDER / ROOFBARS

STOVE ENAMELLED
PERFORATED MILD STEEL
LINER PANELS
ON TREATED SW BATTENS

MINERAL FIBRE
SPRAY INSULATION AND
2 COAT VAPOUR BARRIER
THROUGHOUT

CC TV CAMERA

PORTABLE LADDER
FIXING TRANSOM

15.92

DOOR VENT

15.54

GLAZED VISION PANEL

15.29

SUN VISOR
TO FALLS

2°

SLOPING DOUBLED GLAZED
GALVANISED MILD STEEL
WINDOWS

REFER TO 1812 / A / 527

REFER TO 1812/A/518,519
FOR STAIR DETAILS

INSULATED STEEL DOOR

STAINLESS STEEL
CLAD PLYWOOD
PANELLED CONTROL DESK

FLIP - UP
STAINLESS STEEL
SWITCH PANELS

REMOVABLE
PANELS

LANDING

'ALTRO' NON SLIP VINYL
ON
REMOVABLE PLYWOOD
PANEL SUBFLOOR

'ALTRO'
SKIRTING

STEEL PLATE
TREADS ON
STEEL PLATE STOOLS

STEEL CLAD
SOFFIT WALLS
AND ROOF

CABLE ENTRIES
INTO CABIN SOFFIT

SOLE STAIR
STRINGER

TRAPEZE / STRUT / TIES
TIES TO CABLE LADDER

TWIN CABLE
TIES BACK TO
PLANT ROOM

PRINCIPAL TAPERED RSJ STRUTS
FROM PLANTROOM
STRUCTURE SUPPORTING CONTROL CABIN

CABLE LADDER
(CONTINIOUS CURVE)

CONTROL CABIN SECTION

ELEVATION B:B

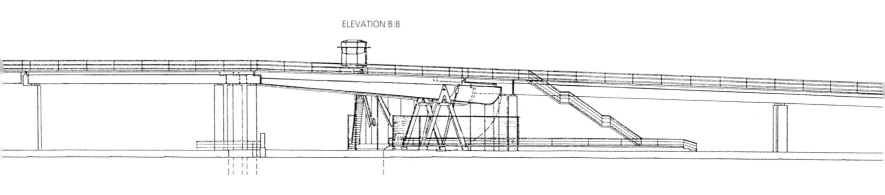

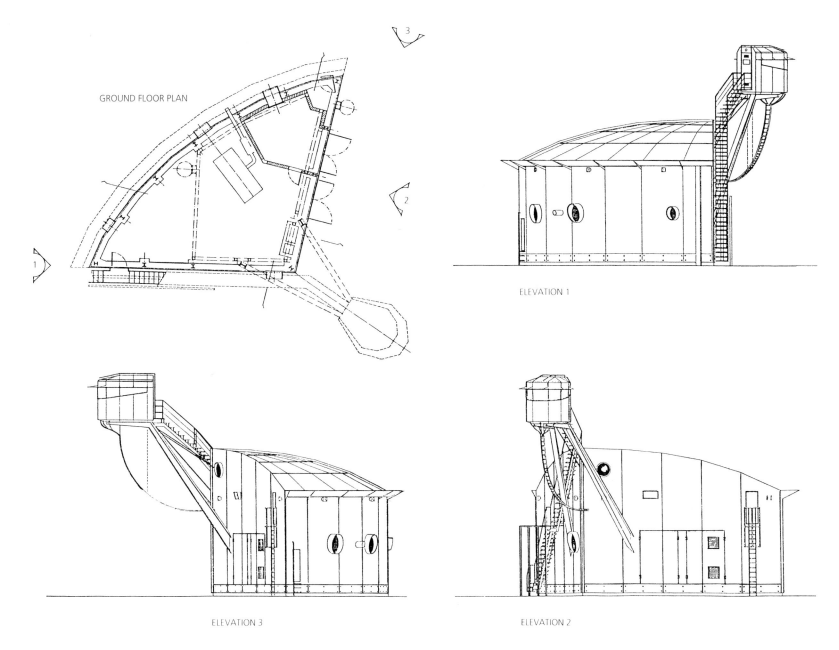

GROUND FLOOR PLAN

ELEVATION 1

ELEVATION 3

ELEVATION 2

ELEVATION A:A

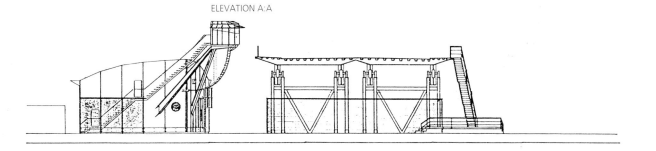

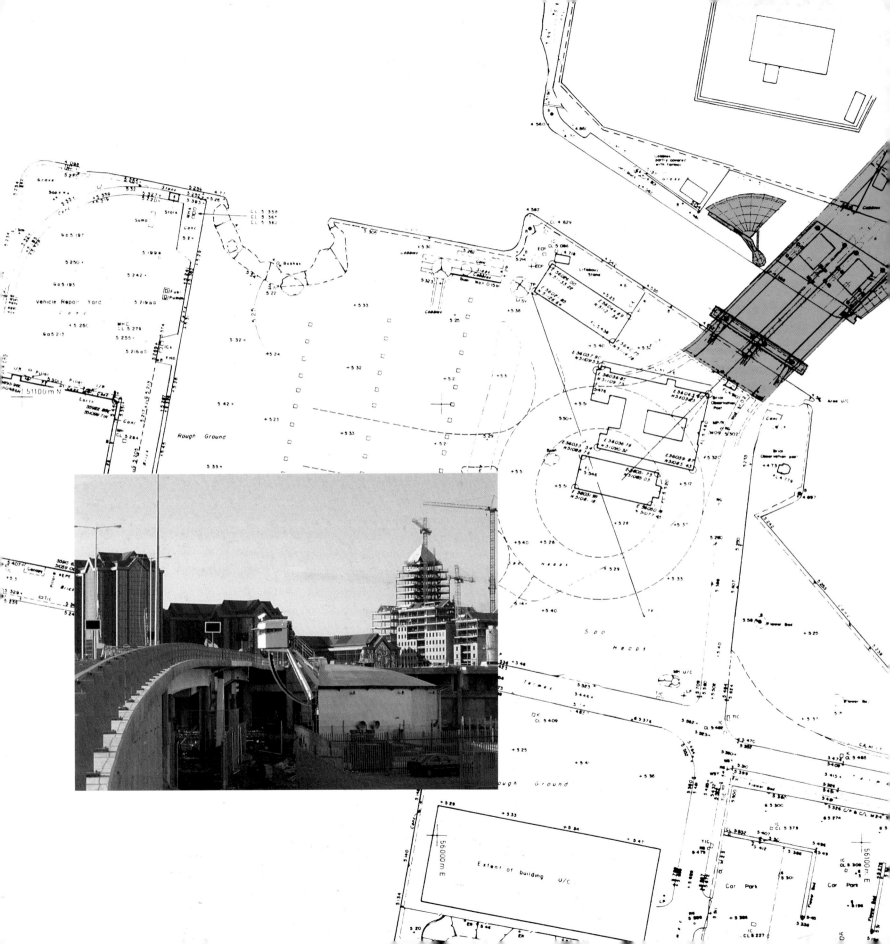

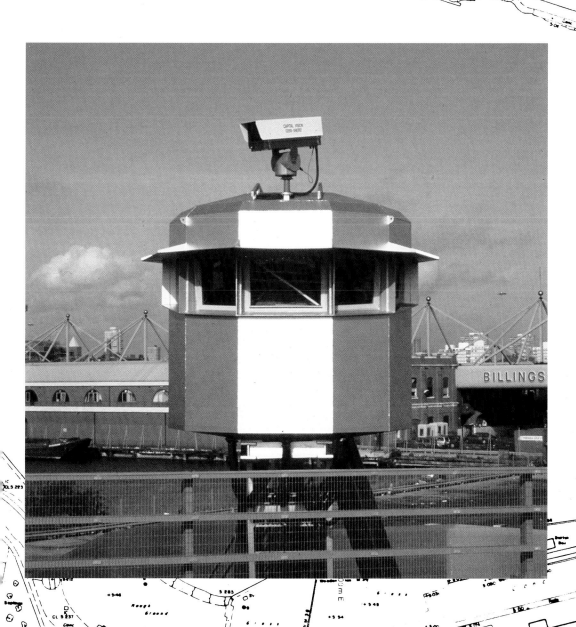

CANARY WHARF

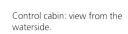

Control cabin: view from the
waterside.

Control cabin: view from the
lifting bridge deck.

LANDSCAPE

Landscape is a major problem for the architecture of our time. English landscape gardening, one of the great arts in history, has degenerated to municipal planting and lawn trimming. Landscape architects talk about problems associated with planting and conserving ('greening' the city-scape), creating and enhancing 'environments', but they have no coherence of concept or strategy; no idea of how the landscape relates to behaviour. They conceive of landscaping as merely instrumental (e.g. conforming to rules governing provision of space for health and safety reasons; creating policeable space, facilitating surveillance) or cosmetic (masking the brutal). We have reached a stage when architects have to define a new attitude towards landscape.

In the eighteenth century, the problems were clearly defined: there was a clientele who knew what it wanted; limitations on travel made it necessary to bring the landscape to where the clients spent their time. Theoretically, the opposite is now true: you can go off in your car or your mobile home and choose your view, compose your own landscape from the window. In fact, not so: Roussel's dream becomes a nightmare in a 'National (Car) Park'.

(Compare this with M. Raymond Roussel's *House on Wheels – Full Scale Motorised Camping* [1926]: 'M. Raymond Roussel did not design and build his caravan – as he modestly refers to it – as a mere whim, without intending to use it. As soon as it was built, the caravan set off last year for a round trip of 2000 miles through Switzerland and Alsace. Every evening Monsieur Roussel had a different view. He returned from the trip with incomparable impressions. This year, at the start of summer, he took to the road to follow his wandering fancy, in search of constantly changing sensations. … It is to be hoped that the example of M. Raymond Roussel will be understood and followed by numerous sybarites and that the day will come when many houses on wheels will run on the world's roads, to the subtle satisfaction of their occupants.').*

We have no shared culture such as that which made the eighteenth century park, for those who had access to it, a narrative to be walked, a landscape to be read (by analogy, metonymy, referential features – temples, obelisks, ruins and statues).

** Trans. A. Melville in* Raymond Roussel, *Atlas Press, 1987.*

Where to begin? What is required? Function follows behaviour.
A different set of abstractions, perhaps:

Celebration

Tranquillity

Play

Movement

'densities of experience/ expansions of experience'.

How to make a building, a place, a park, a city street, a bridge, rich in possibilities of reading, productive of unintended, unforeseen meanings: like a poem. (Lenin said 'let everything be temporary'.)

The long footpaths (coastal / coast-to-coast / Pennine Way / Offa's Dyke) are linear parks: settings for behaviour: they start somewhere, go through a landscape which continuously changes but has a unity, a programme.

In the Cardiff Barrage, the problem is essentially one of ambience and circum-ambience; the architectural problem is not one of structure so much as what one does with the structure, which must take a given form. Like a footpath, the Barrage can be seen as a linear park which is also an object; it is a structure that can be seen as a long promenade, a kind of pier, a walkway. It may develop new uses as a consequence of the behaviour of those who come to it, walk it, fish from it, play on it, watch others using it. A park is modified by the games it makes possible.

Colour will play a role; objects and structures will be ambiguous; games will be possible: a series of activities, related to the ambulatory aspect, or the play aspect, will be proposed by aspects of the structure, and objects on it. It is an object and an experience. It's a mile long.

Landscape now presents a major challenge to artists and architects: problems of definition; tasks of realization: it cannot be divorced from building buildings: compare this with Le Corbusier [1945]: 'Man has made a mock of the provisions of nature, and the sport has cost him his life. The conditions of nature must be re-established in men's lives for the health of the body and the spirit.'

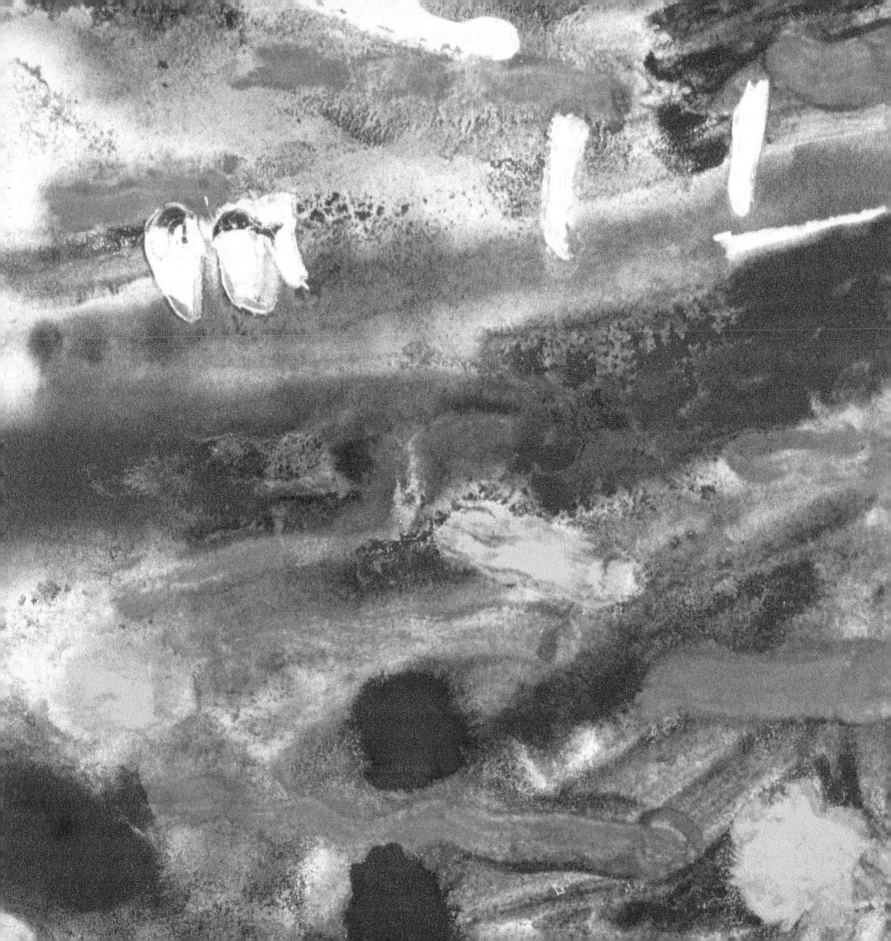

BORDEAUX
River Garonne
Activator

The city of Bordeaux invited seven architectural practices to submit ideas for the development of the port area. Alsop and Störmer were asked to produce proposals for the River Garonne itself. The scheme is for a long chain of linked sections which connect to the bank at three different points, but without ever completely spanning the river. The sections move from side to side in response to the flow of water and are semi-submerged at high tide. Their transparent casing allows for unhindered views up into the sky and down into the water.

This 'Garonne Activator' could accommodate unlimited functions. As a floating building it could be used for almost any purpose: a disco, a supermarket, a cathedral. A cluster of high-tech sails acts as a series of billboards – travelling left and right with the (political) wind. Around the structure bob large flowers which could open and close their petals in response to light and sounds or be linked to control points on the bank so that the public could direct their movements.

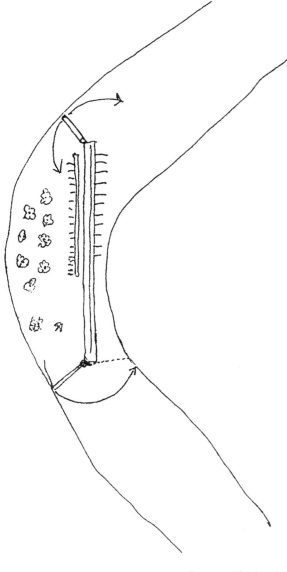

previous page: Alsop's water-colour sketch for the River Garonne 'Activator', Bordeaux.

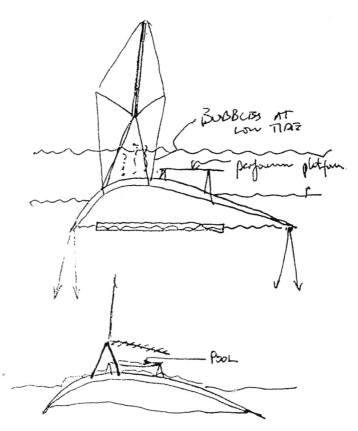

The Activator: cross sections.

Low tide showing the
Activator above water level.

High tide, the Activator is
submerged but art sails and
carbon fibre rods are visible
above the water.

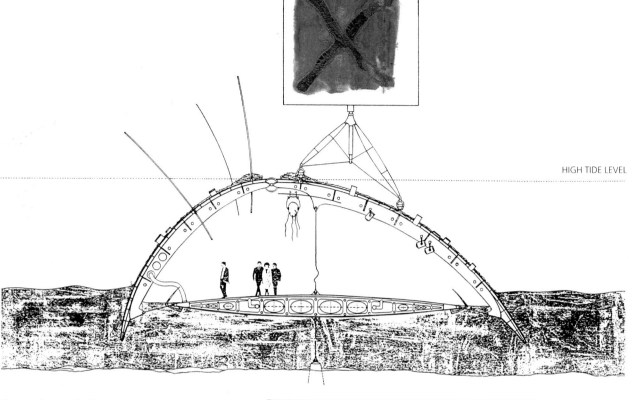

HIGH TIDE LEVEL

Cross section showing the
building's position relative to
low and high tides.

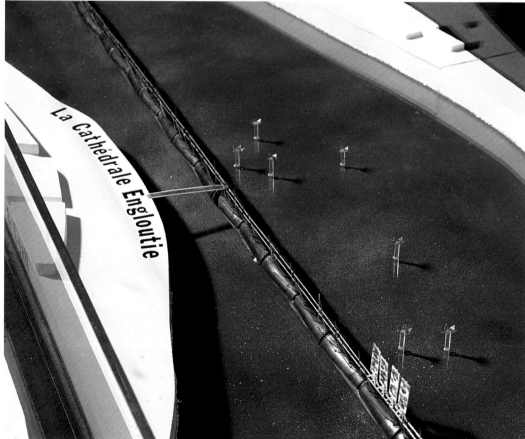

La Cathédrale Engloutie

Model of the Activator at low
tide. Art sails are visible,
lower right. Environmentally-
responsive 'flowers' are
tethered to the river bed
alongside.

Art sail boards mounted on the Activator display work by local artists.

CARDIFF BAY
Barrage

The Cardiff Bay Barrage will contain a large area of inland freshwater lake and provide a new route from Cardiff city centre, through the docklands to the Victorian suburb of Penarth. In the plan proposed by Alsop and Störmer, a utilitarian piece of civil engineering is transformed into a giant artwork. The structure follows a sinuous curve from one bank to the other, punctuated by a series of architectural events: brightly coloured structural elements, planting, picnic spots, fishing piers, even a specially created island.

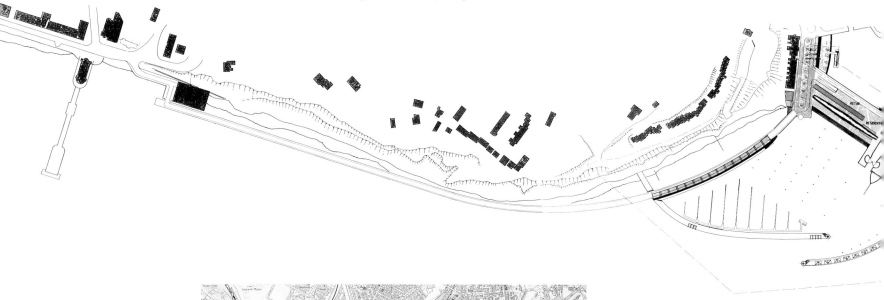

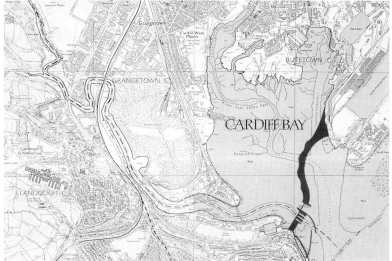

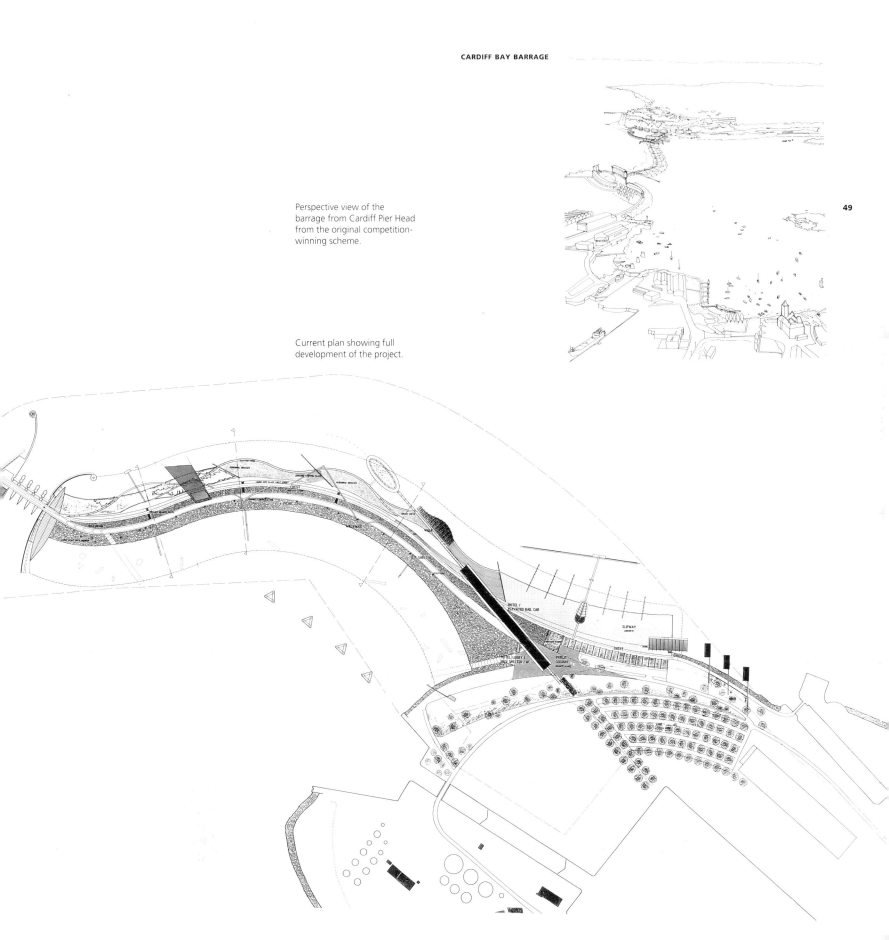

Perspective view of the barrage from Cardiff Pier Head from the original competition-winning scheme.

Current plan showing full development of the project.

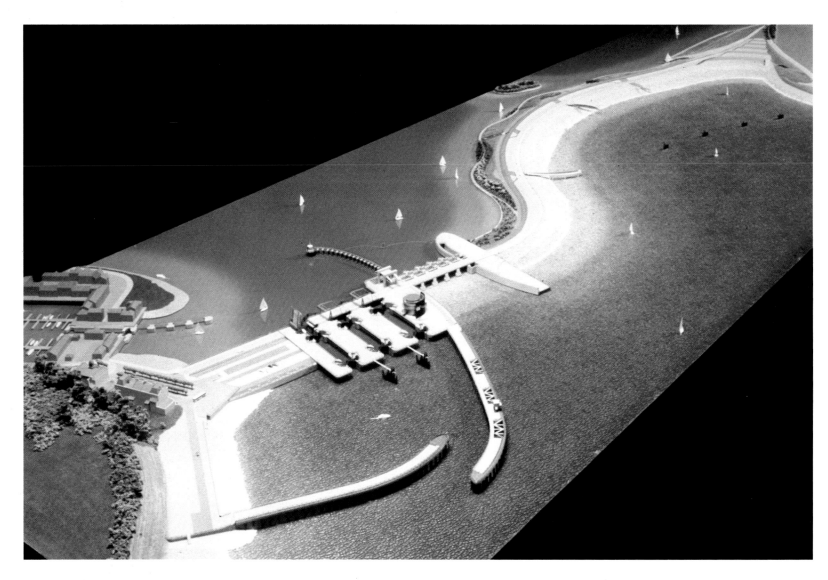

Presentation model prepared
for the Parliamentary Bill.

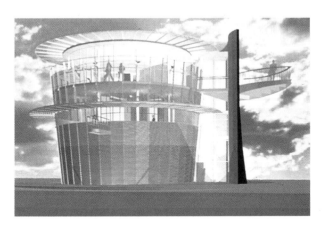

Computer-generated image
of the Control Tower.

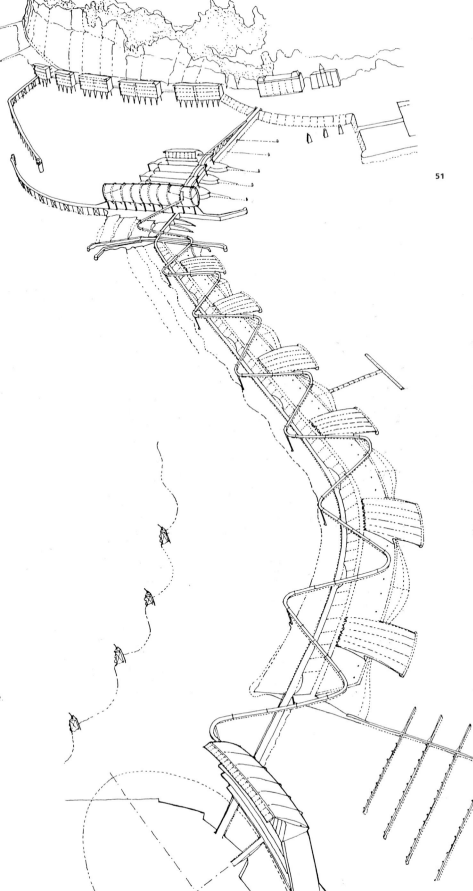

View from Cardiff towards
Penarth showing elevated
walkway, from the original
competition-winning scheme.

STRUCTURE /
DECORATION

Le Corbusier: 'The Engineer, inspired by the law of economy and governed by mathematical calculation, puts us in accord with universal law. He achieves harmony.'

There is a long and fruitful history of collaboration between structural engineers and architects in this country. They have shared a culture; they have acknowledged a common interest in good buildings. Elements of pure engineering can suggest beautiful solutions to architectural problems.

Engineering has become an integral part of the architecture: not only structural engineering, but environmental engineering. In the series of proposals for the British and European Pavilions at Seville and Marseille which represent a unified progression of thought, the shape and forms of the buildings are totally related to a maintenance of atmospheric control by means of the natural circulation of air: structural support, form, the internal climate are all integrated to create a specific combination of form and space to meet a particular brief. (nb what people will do in that building, how they will use the given spaces, cannot be predicted. Any brief is in that sense provisional.)

Modernist purist axioms with reference to structure: do the most with the least / support the maximum load with the least material. (Ally with nature.) The spiritual implications are various: compare this with Malevich: 'I declare Economy to be the new fifth dimension which evaluates and defines the Modernity of the Arts and Creative Works. All the creative systems of engineering, machinery and construction come under its control, as do those of the arts of painting, music and poetry, for they are systems of expressing that inner movement which is an illusion in the tangible world.'

Such economy can be found in the Gothic. The roof of Norwich Cathedral is a

supremely beautiful thing which is the consequence of an absolutely economic structural solution to a given problem, which performs at the same time a spiritual (ideological) function.

But see Alsop contra purist structural solutions: 'Wherever you look at the Gothic there is the element of decoration: and that aspect is necessary to it. Decoration is necessary to our well-being.' (The Gothic architect knew that there would be decoration, and what it would mean. And it didn't need justification.)

(Compare this with Emile Mâle: 'To the Middle Ages art was didactic. All that it was necessary that men should know – the history of the world from the creation, the dogmas of religion, the examples of the saints, the hierarchies of the virtues, the range of the sciences, arts and crafts – all these were taught them by the windows of the church or by the statues in the porch. … Conviction and faith pervade the Cathedral from end to end … [to the men of the Middle Ages] it was the sum of revelation. Man, cramped by his social class or his trade, his nature disintegrated by his daily work and life, there renewed the sense of the unity of his being and regained equilibrium and harmony.')

Contemporary decoration (stuck-on bits of sculpture/ mosaic/ tiling) is imaginatively poverty-stricken. How, then, to create a modern decorative richness integral to the structure and meaning of a building? The problem is ideological: i.e. at the heart of architecture. The problem is also professionally radical: i.e. at the point of contact between architect, engineer, and client/society.

(Compare this with Decorative arts of Russian Constructivism: Malevich's cups and saucers; Burylin's and Popova's and Stepanova's textiles.)

It is a problem for artists, philosophers, politicians, theologians, as well as for designers and architects.

SEVILLE, EXPO 92
British Pavilion

This second-placed design for a pavilion on the theme of 'A Celebration of British Inventiveness' developed from the need to provide a stunning piece of architecture which would itself 'perform' and capture the attention of visitors to the Expo. As a result, the building was conceived as a sequence of events, responding dynamically to internal demands and adapting to environmental variations. The roof opens up in the heat of the day to release a silver airship which hovers above the pavilion and deflects the sun's rays. At night its underside can be used as a projection screen. The main exhibition area has a transparent glass-block floor with fountains below; an internal courtyard contains a continually circulating, four metre wide channel of water; the hull-shaped audo-visual dome is cooled by the water running down its curved timber wall. The east wing of the pavilion has an 85 metre long external wall which lifts entirely, allowing the space to act as a stage for concerts or fashion shows and providing a means of entry without queues.

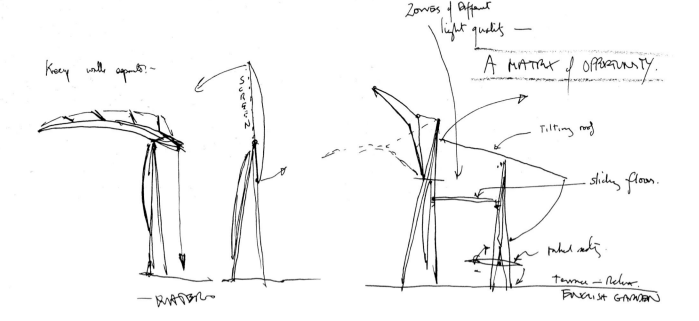

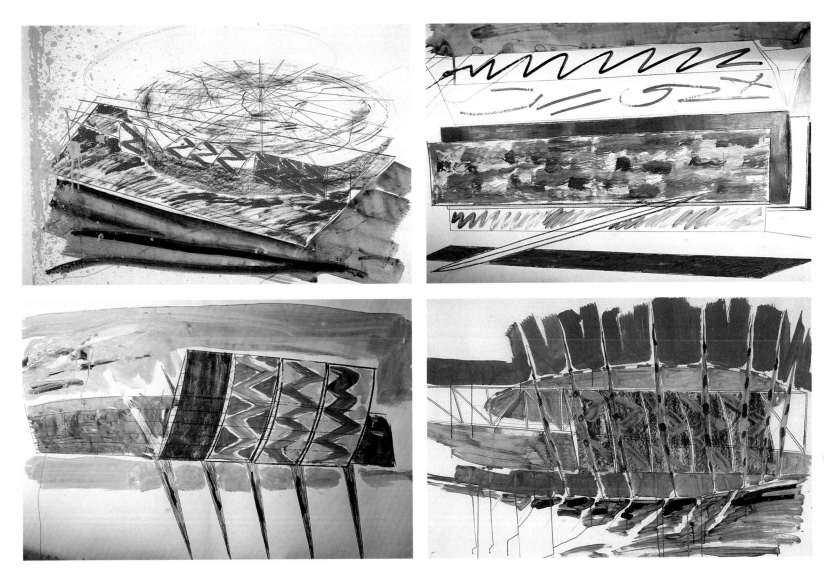

Preliminary sketches and
paintings for the project.

56

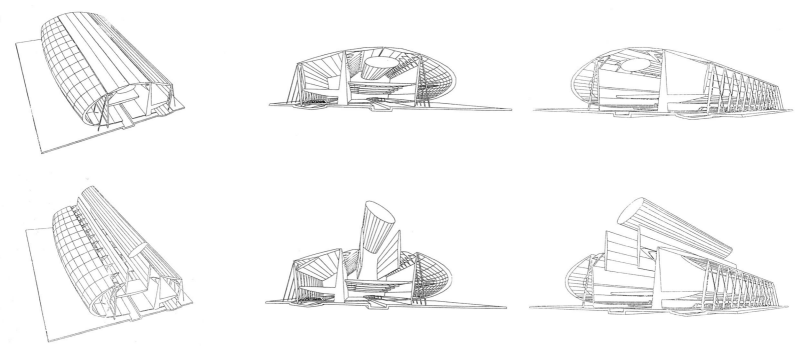

Alsop's first use of computer-generated graphics showing the building in its various states of movement.

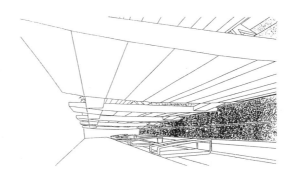

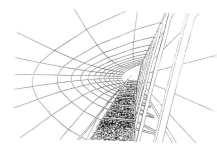

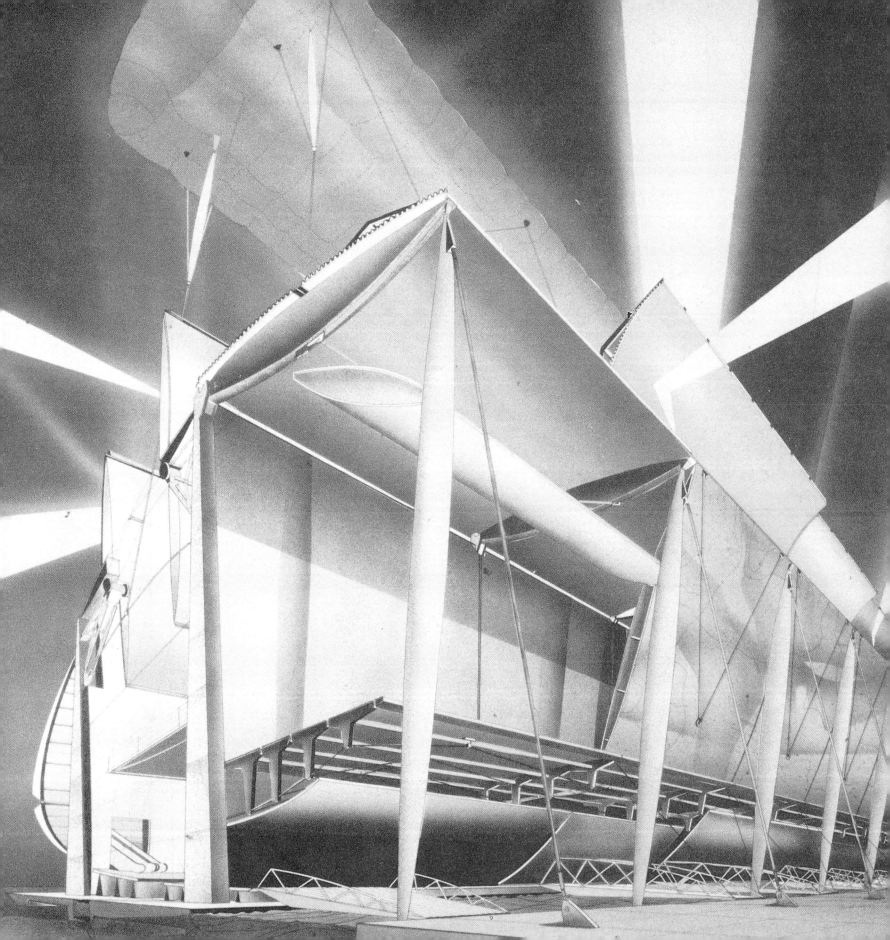

58

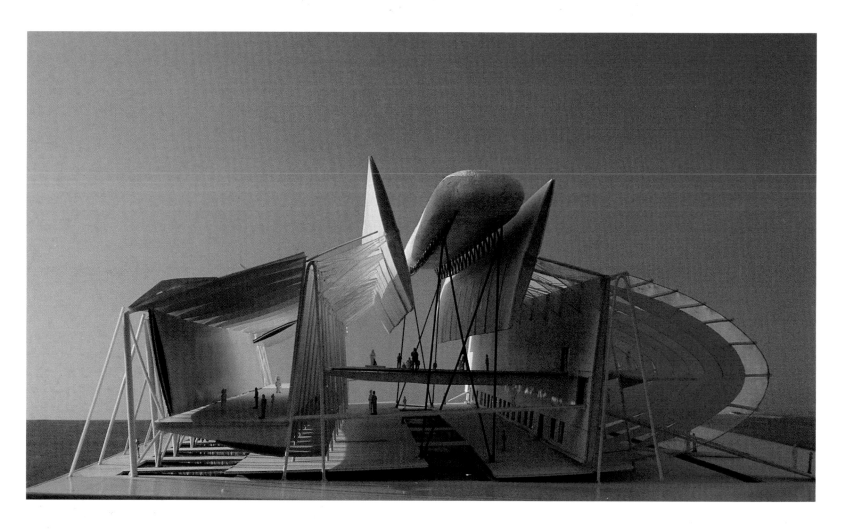

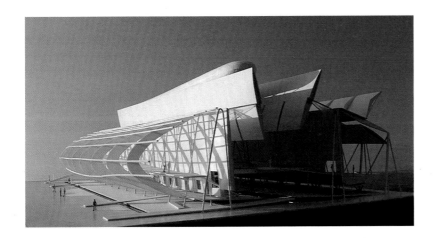

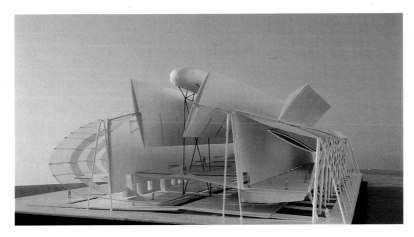

The competition presentation model: the building is shown partially opened with the climatic control inflatable structure floating above it.

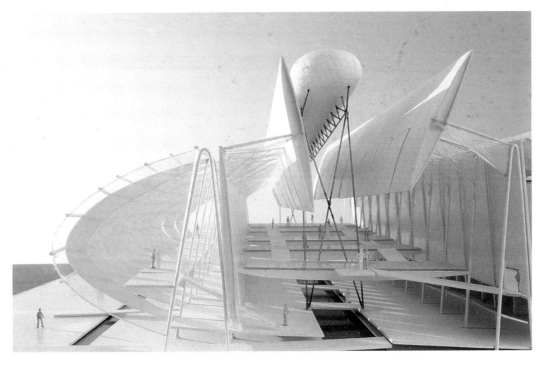

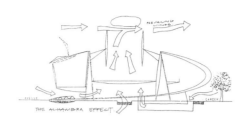

THE ALHAMBRA EFFECT.

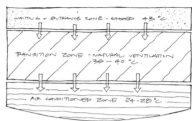

PATH OF THERMAL ACCLIMATISATION THROUGH BUILDING.

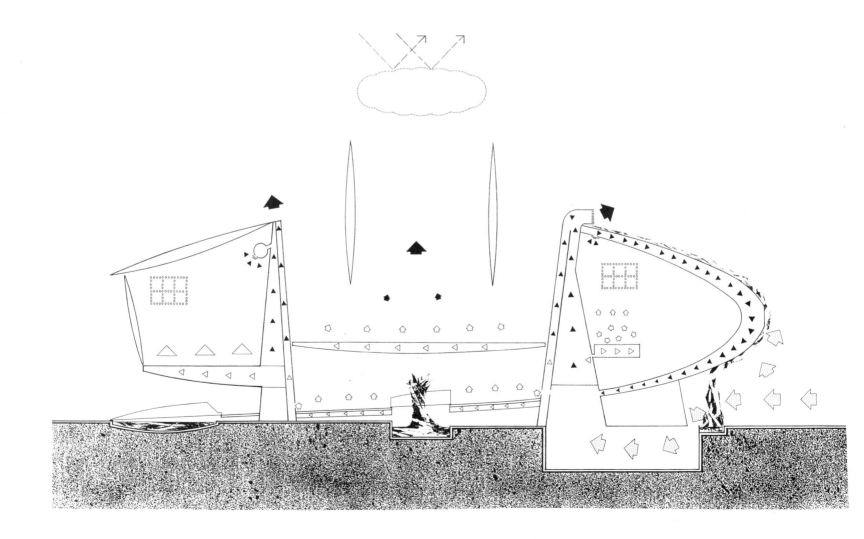

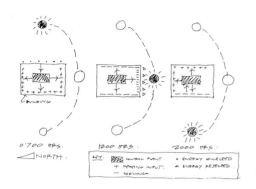

0·700 HRS.
△ NORTH.

1200 HRS.

2000 HRS.

KEY: CONTROL PLANT.
+ HEATING INPUT.
− COOLING.
◦ ENERGY COLLECTED
△ ENERGY REJECTED

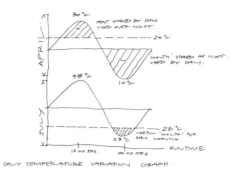

DAILY TEMPERATURE VARIATION GRAPH.

Cross section and sketches demonstrating the building's active and passive systems of environmental / climatic control.

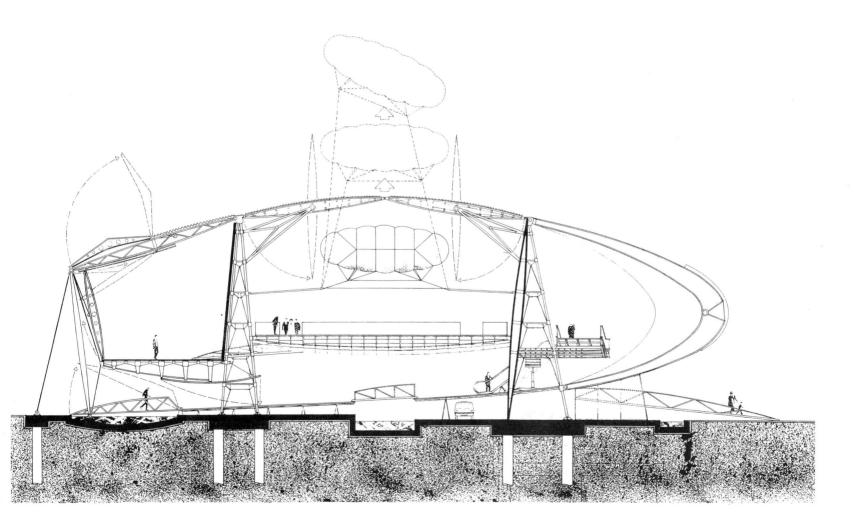

**MARSEILLE
Hotel du
Département**

This £100 million commission, won in competition with 156 other designs, uses simple linear forms and inventive engineering solutions to provide flexibility of function and use. One of its central aims is to enrich the experience of moving into and through its internal spaces. The structure consists of two rectangular administrative blocks and a cigar-shaped assembly hall connected by bridges and walkways suspended in atria. Simple materials – concrete, solar glass, timber and steel – and low-cost technologies are combined to create a sophisticated relationship between the internal and external environments: for example, the design minimizes the need for air-conditioning by using the wind, low-energy fans, atria with adjustable roof vents and surrounding layers of different materials to cool the building.

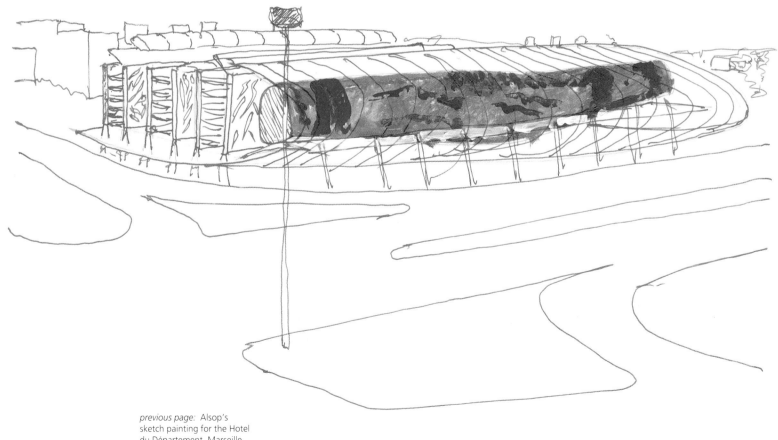

previous page: Alsop's
sketch painting for the Hotel
du Département, Marseille.

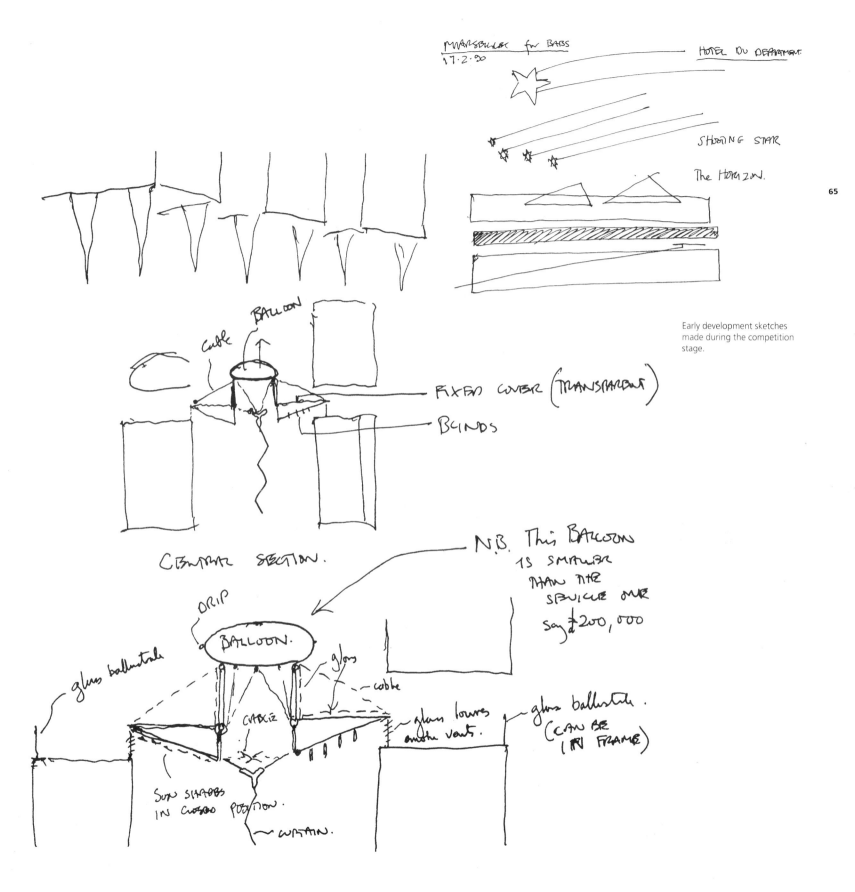

MARSEILLES for BABIS
17.2.90 HOTEL DU DEPARTMENT

SHOOTING STAR

The HORIZON.

65

Early development sketches
made during the competition
stage.

CABLE BALLOON

FIXED COVER (TRANSPARENT)

BLINDS

CENTRAL SECTION.

N.B. This BALLOON
IS SMALLER
THAN THE
SERVICE ONE
Say £200,000

DRIP

BALLOON.

glass balustrade

glass

cable

CABLE

glass louvres
onto vents.

glass balustrade.
(CAN BE
IN FRAME)

SUN SHADES
IN CLOSED POSITION.

CURTAIN.

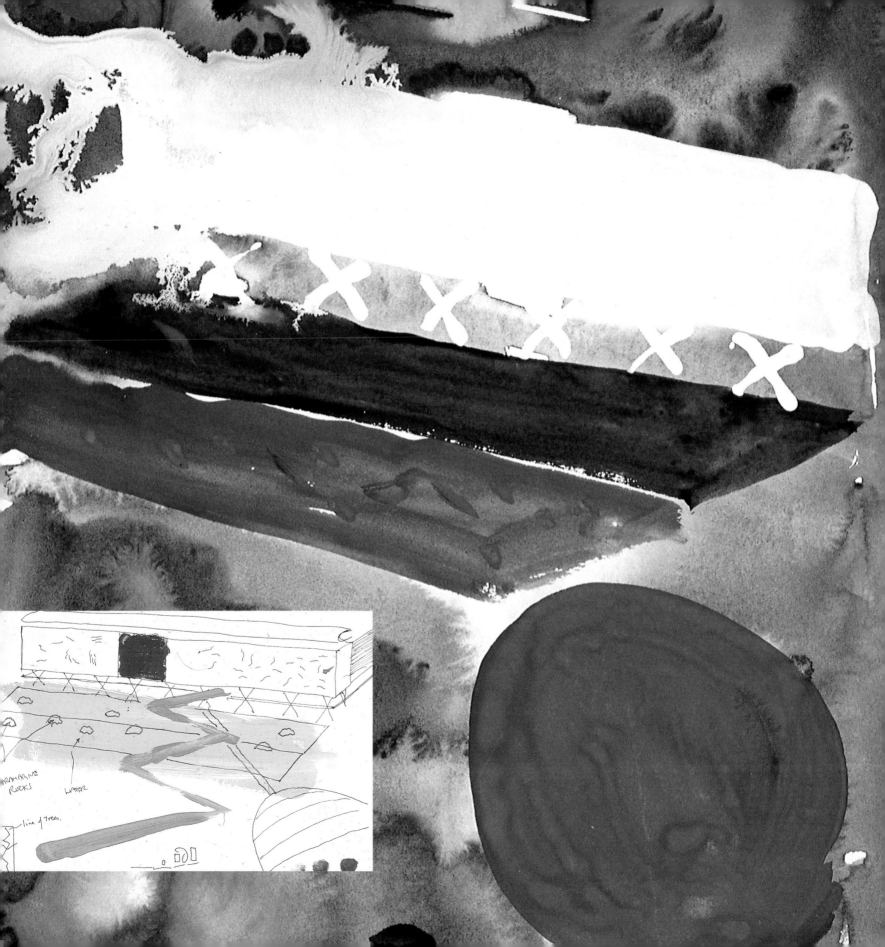

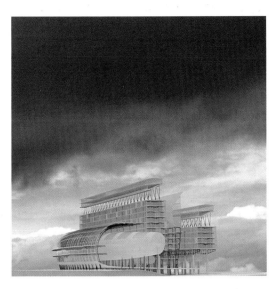

The first study model made immediately after winning the competition.

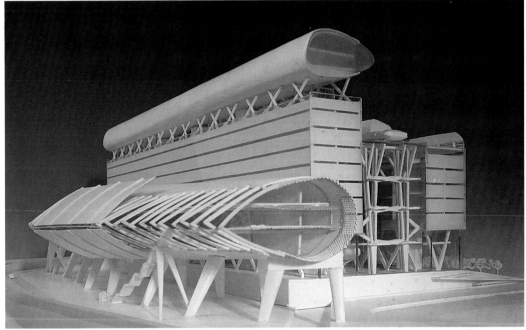

Planning approval model.

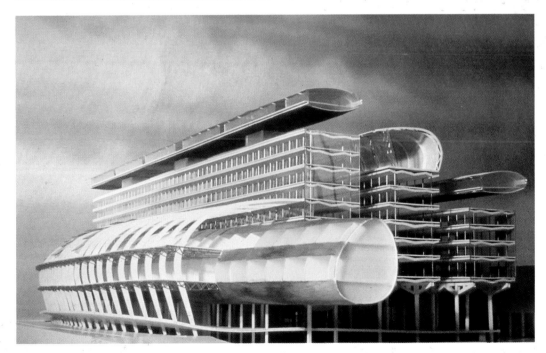

Detail of the second-stage competition model.

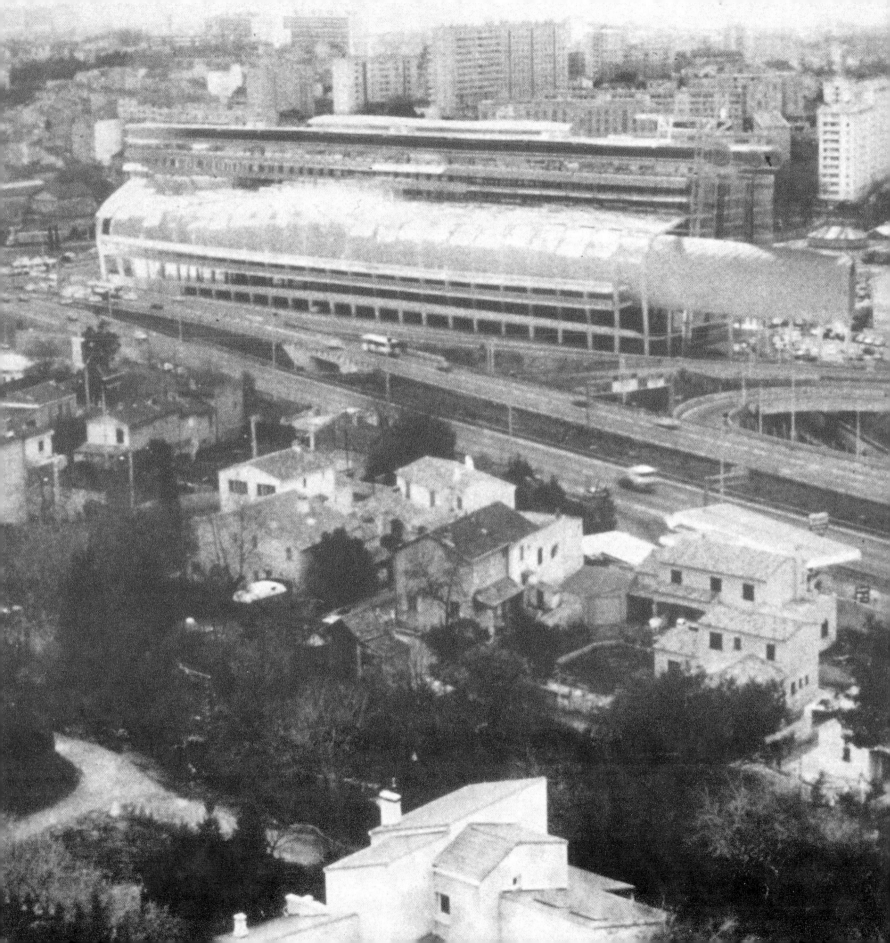

Photo-montage for the first stage competition.

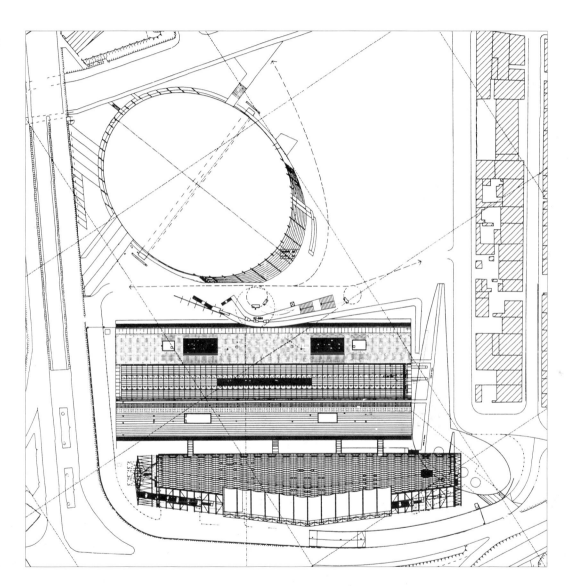

Site plan of current scheme.

Computer model of the Aviary structure showing its ribs and stainless steel tension mesh cladding.

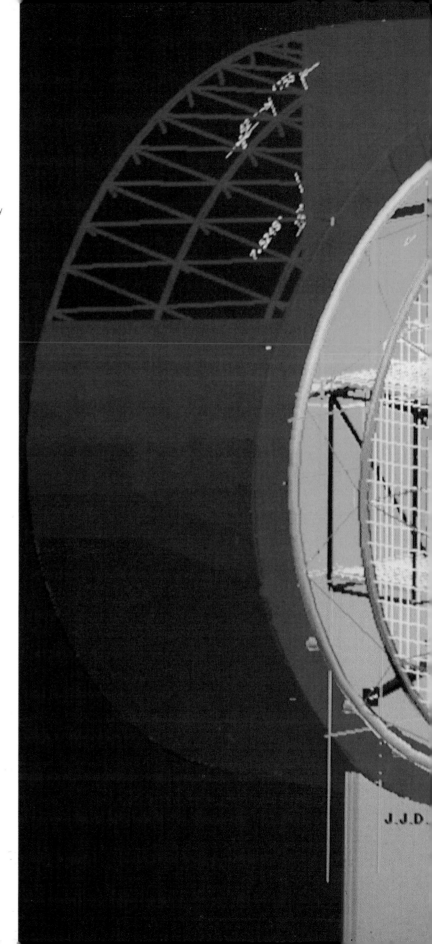

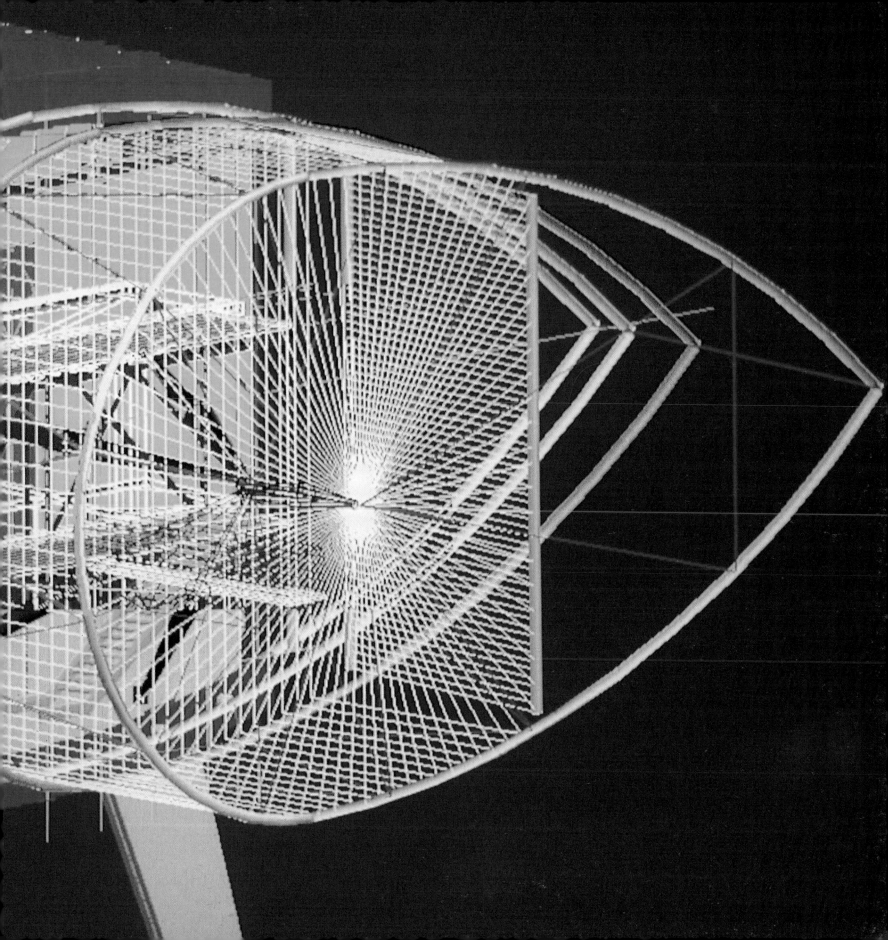

72

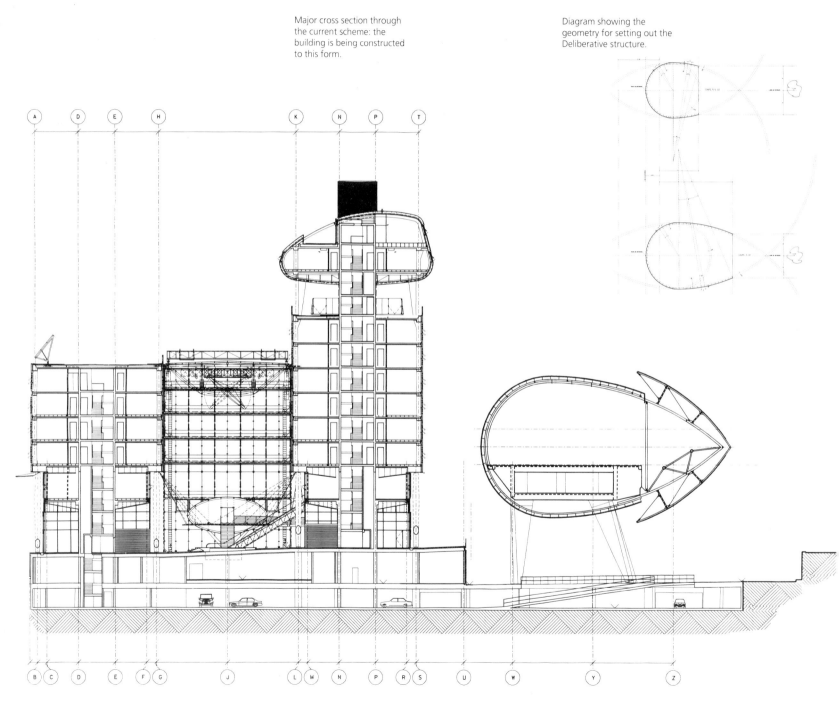

Major cross section through
the current scheme: the
building is being constructed
to this form.

Diagram showing the
geometry for setting out the
Deliberative structure.

Detail of the atrium roof
showing sun screens and
reflective baffle which
follows the sun's path.

74 Views of the final pre-construction presentation model; the finished building will take this form and colour.

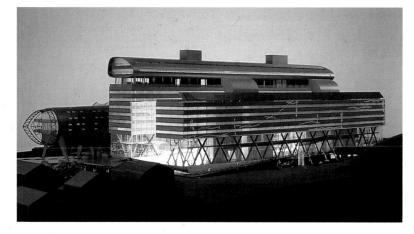

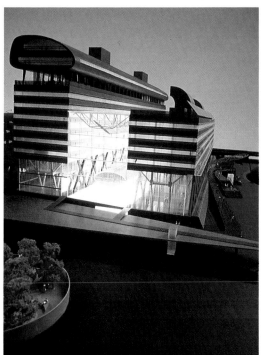

Detail of the kinetic structure in the building's forecourt.

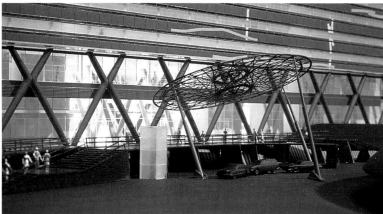

View into the atrium showing the roof structure and ovoid 'mist'.

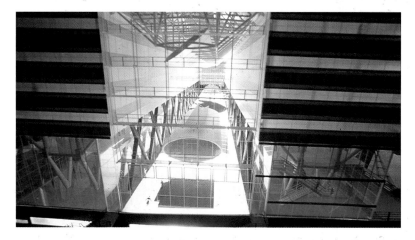

View of the Deliberative chamber and the 'sperm' roof over the metro.

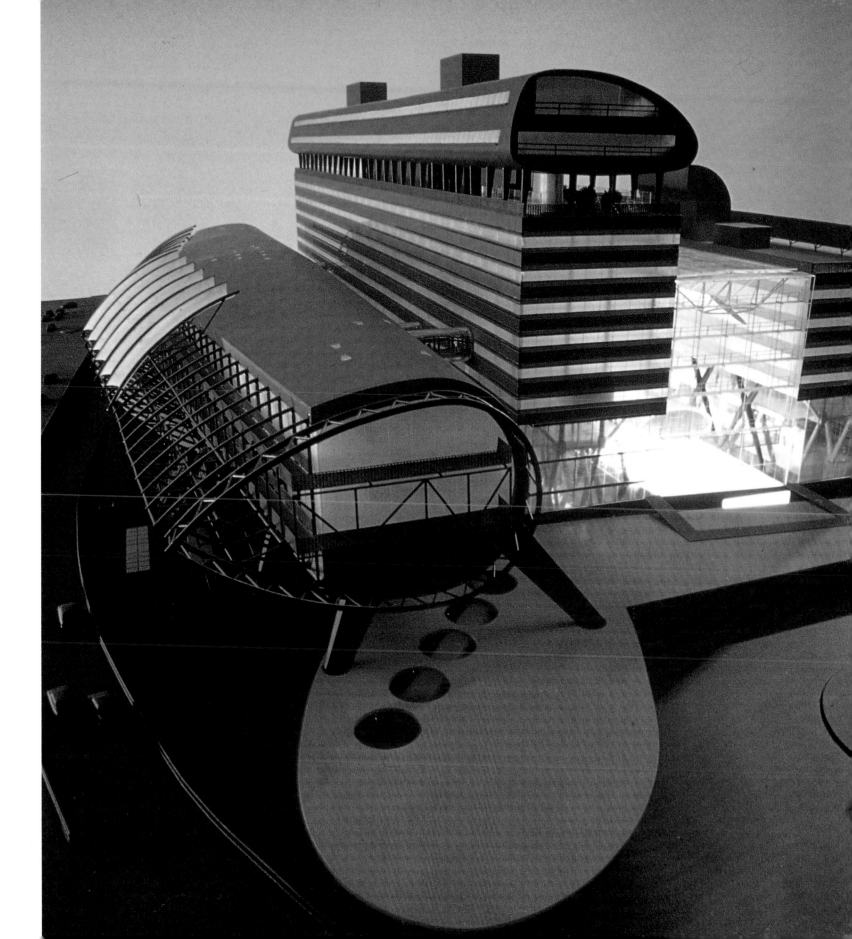

DRAWING AND PAINTING

Alsop: *'The production of a diagram is not a particularly good way to explore the world.'*

Drawing had seemed important at the beginning; it took time for Alsop to understand why, that for the student architect, the drawing was the product. Alsop: 'A drawing as a drawing may be commendable, but it may obscure the architecture it intends to convey.' Archigram's idiosyncratic uses of drawing and collage especially impressed the young student at the Architectural Association.

Working with Cedric Price changed that. Price's use of drawing and combined diagrams was 'very dry, but full of content'. Others, Archigram among them, made drawings designed for impact as opposed to the encouragement of lengthy looking and contemplation. In any case, Alsop early on lost interest in depicting the building: it was the system and the essence of the idea behind it that mattered. The question was: how to see those abstract things through drawing?

At Riverside Studios in the early 1980s the question arose in a new context: how to work with an artist to realize architectural ideas? Alsop had worked with Gareth Jones at St Martin's School of Art. At Riverside, over two or three months, they produced, independently (in a procedure developed at St Martin's), at least one drawing every day, often more, with little or no talk about the project. For Alsop, this was the first time a proposal was developed without having to make decisions or present an idea until late in the process of thinking; and the thinking had been itself collaborative and visual: a 'dialogue' of drawing, not talking. Later they worked with large drawings, ceiling to floor, ten, twelve feet high, using only fat pens (1.0mm). These were time-consuming, and Alsop became suspicious of the method, of the trap that this might be drawing for drawing's sake rather than drawing for discovery. A new way was indicated.

In 1985 came the Hamburg project. The presentation for the initial stage was the first made entirely with paintings. These showed a route through the centre, and buildings ('or were they buildings?' – it didn't really matter). They discovered a strategy; the paintings were colourful, bold, quick to make, and they were all used. The presentation was successful.

Most importantly, the paintings lacked the authority of detailed drawings: they did not threaten a solution, they did not dictate terms: they proposed a dynamic, a feeling about possibilities. In this they reflected more truly the process of Alsop's architectural thinking; and they showed a way in which that thinking could be kept fluid, explorative, un-finalized, even while a presentation was being prepared and made. A means towards a new way had been found.

Working with Bruce McLean during 1985 Alsop took this further. It took a while to develop a personal mode: McLean's was a powerful presence for some time; escaping the 'Bruce effect' was necessary. During a memorable Saturday morning they painted alongside each other, on large sheets of photopaper using a much larger brush than Alsop had been used to: a breakthrough; painting as a way into a project was confirmed as a procedure. From McLean's practice of making on large sheets of photopaper or on canvas what amounted to sketchbook drawings (adumbrative, explorative, provisional) – breaking free of constraints determined by scale – Alsop learned a mode of 'large thinking'. It was the opposite of the fabled thumbnail sketch, the grand design projected on the napkin over lunch.

'With the painting on the large scale you are using your whole body; you have a completely different relationship between yourself and the imagined building, which at that stage is purely abstract anyway: there is a true dialogue between the two; it's possible to become elated without being trapped by a conceptual precision. It's quick; if it doesn't continue to excite you, you can do another.'

There are other limitations to the thumbnail sketch: it has to do with 'seeing the building whole', but we rarely experience a building as a whole, and only then as a 'distant prospect', a sculptured structure seen from a distance, an object, not a function. The thumbnail sketch, like the diagrammatic representation (prospect / elevation) falsifies our real experience of buildings and the spaces in them, which is partial. The paintings became more abstract, and were made on canvas: change the support, shift the mode. That you couldn't 'see' the building in the painting didn't matter; illustration was not the point.

Painting became the means to imagine solutions without knowing too much about the problems, an abstracting strategy, leading straight to the initial models; or a procedure that enables the problems to be re-conceived. Alsop's paintings moved on from the adumbration of forms and proposal of spaces to become a means to imagine the experience of a building. Beyond that, painting has become an end in itself; a means to free the mind of architecture, a form of play.

'Sometimes I paint with no building in mind at all; it's a continuous process of research.' (Compare this with Cedric Price: '…To maintain a valid role in a constantly changing society, continuous anticipatory design is required of architects. Instantaneous response to a single architectural demand is too slow. … Fortunately, the achievement of calculated uncertainty is recognized by an increasing number of architects as a major function of architecture.')

In the Academy at Munich the architectural students paint as a procedure: they call it 'Alsopping'.

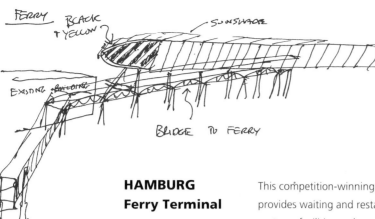

HAMBURG
Ferry Terminal

This competition-winning design for a ferry terminal on the River Elbe at Hamburg provides waiting and restaurant amenities for passengers, office accommodation, customs facilities and a comprehensive plan for the parking and queueing of cars and freight containers. The main terminal building is a precast concrete-framed structure repeated over a length of 500 metres with variations to accommodate different uses. It is raised on stilts to allow cars to circulate beneath it and to protect it from damage should the river flood. Its dramatic curves and materials – glazed curtain-walling giving passengers uninterrupted views over the water, natural-finish zinc cladding and a translucent plastics membrane roof – echo the scale and forms of the ships that draw up alongside. It is separated from the office accommodation by a strip of water to emphasize the act of passing through customs control into Germany.

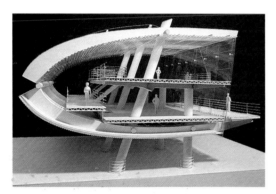

Model and sketches of the original competition-winning scheme.

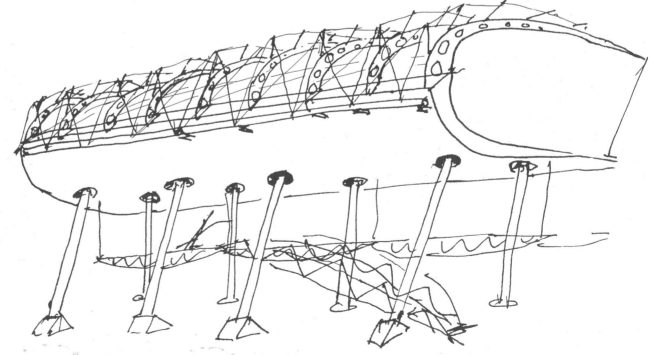

HAMBURG FERRY TERMINAL

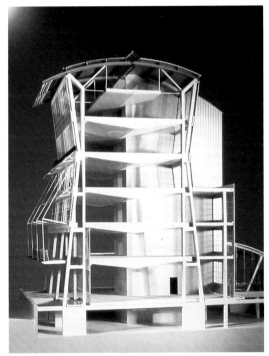

Model views of the final
scheme. It will be built in
three phases with a total
length of 500 metres. The
design changes from the
competition scheme were
made according to the ferry
company's requirements.

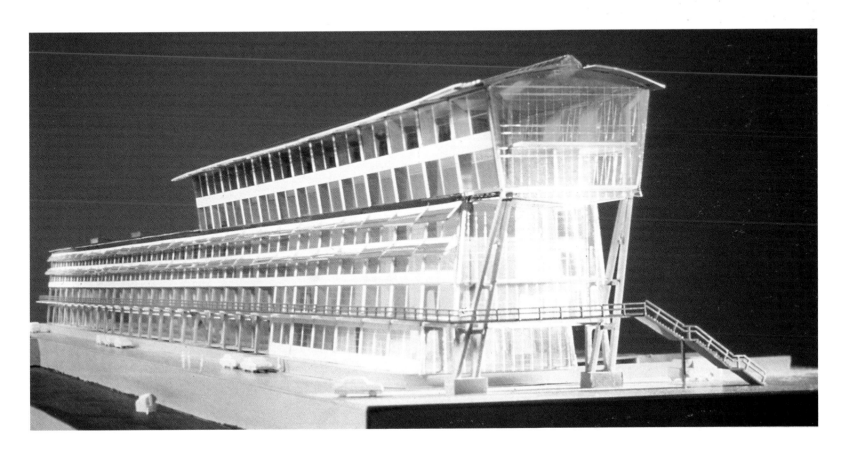

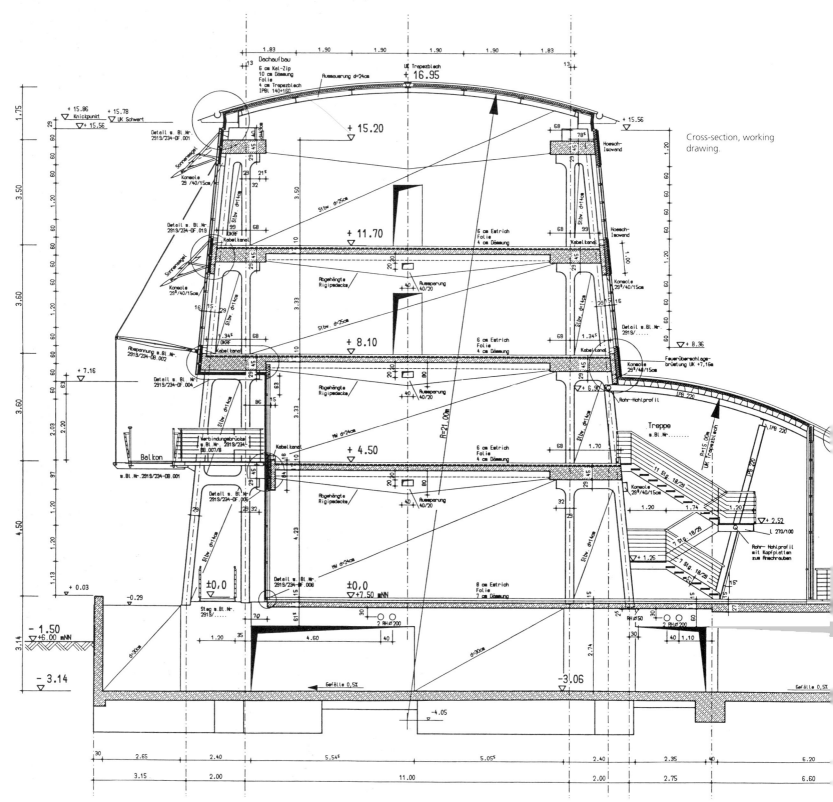

Cross-section, working drawing.

80

Roof / wall junction detail.

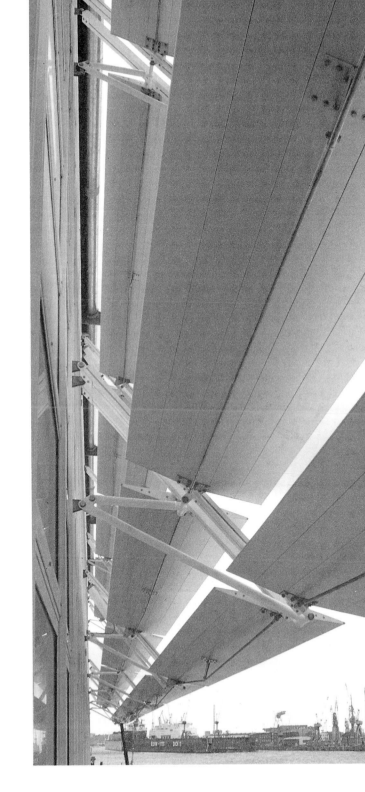

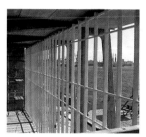

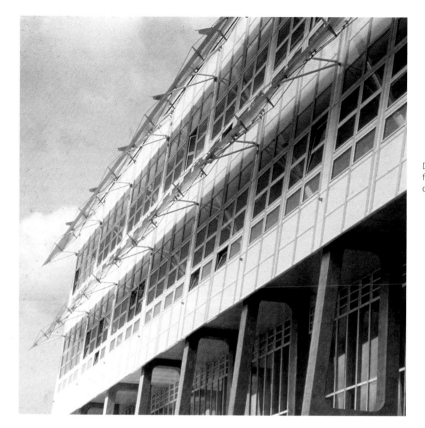

Detail of the pre-cast concrete frames and cladding structure during construction.

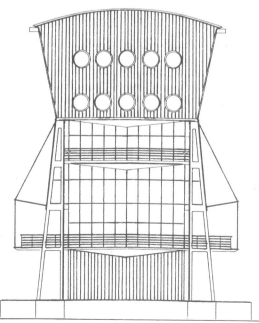

END ELEVATION

DOCKSIDE ELEVATION

Up-view of the brise soleil on
the dockside elevation.

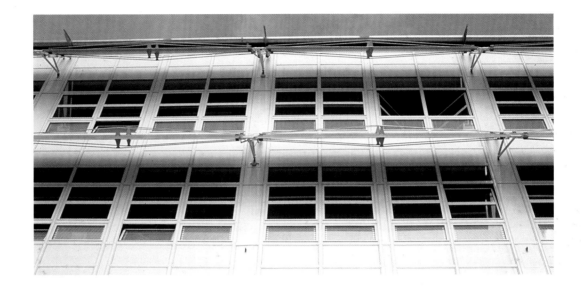

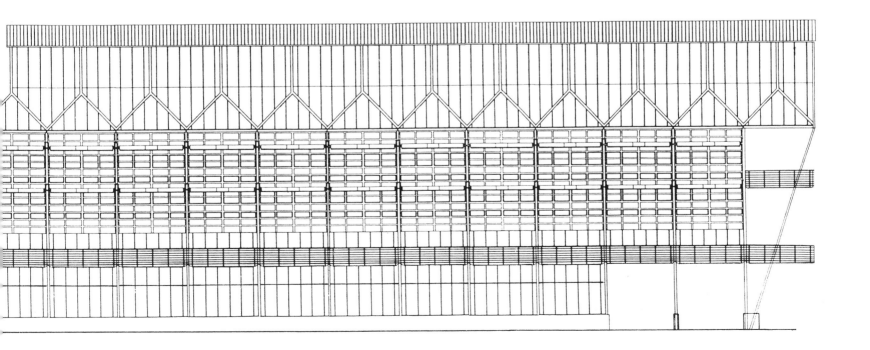

**PERSONALITY /
EXPRESSION /
LANGUAGE**

There is a school of thought that dictates that each project should be taken on its own terms, and every next project should be seen as different from the last: each building is unique. But if you consider the work of an artist, the idea that each painting or work should be radically different is absurd. Why should architecture be regarded differently? 'For me each new project now is like the next painting by a painter.' Change takes place over a period: there is certainly progression over time; things are taken up, things dropped, things rediscovered. For example Marseille culminates a process begun with the proposals for pavilions (British / European) in Seville.

The difference is that making buildings takes a long time, and is a matter of negotiation within constraints: economic, political, social, aesthetic. But the work of imagining a building can be very fast. A good painting session on Saturday morning may lead to the essential ideas for a project being realized by the end of the weekend. After that, the negotiation begins. Creativity and ingenuity continue to play their parts in the process, but the imaginative impetus has its beginnings in the act of thinking in painting. Can the analogy between artist and architect be sustained?

The history of an artist's work is the history of the artist's gradually evolving expression: the artist works from within the centre of his own consciousness: the work has the authority that comes from that particular author. But Alsop's work is not expressive; it is not a matter of an individual manner imposed upon each project, of characteristic forms adapted to new purposes within a unified style. Alsop rarely speaks of 'buildings' as objects or forms that he would like to create

or see; rather he talks about behaviour or about objects that might provoke or create sorts of behaviour.

For Alsop, painting is a means to develop an architectural language; a way of discovering and expressing thought. Others may use other strategies: '… but it is a language I will not protect. I will not say this is my language as opposed to another architect's language, because I am quite happy to contradict myself if the ideas developed through it are not demanded by the requirements of a commission'.

The minimalist blandness of Modernism (a project of redefinition of classical forms, their combinations and usages) was intended to emphasize that the true life of buildings, their actual language in its true articulation, consisted of the behaviour of the people in them: it was a clear page upon which people would have the freedom to write their own lives. Alsop: 'And that I would hold close to my heart.'

But there is something else: the lifting of the spirit through architecture, and that can only be done by going beyond language to pure experience. There is a possibility then of a building in which the norms and forms of given architectures are stripped away; which might perform many functions depending upon the behaviour of the people in it and their needs at a given time? That is to think in terms of space not of structure.

Alsop is realistic: 'In architecture, as in art, everything in the end is an outcome of cultural agreement; there is an accommodation between where the architect thinks he could go with an idea, and what he can do with the materials and the circumstances.'

**AMIENS
Urban
Interventions**

AN EXTRORDANARY
WALL.
IT WILL CHANGE
IN RESPONSE TO.?

AN EXTRA ORDINARY
FLOOR.
IT WILL CHANGE
FOR A VARIETY
OF EVENTS.

TOURISTS COME / PEOPLE FROM THE REGION
COME — TO DANCE & TO LOOK

Pages extracted from Alsop's
early project sketchbook.

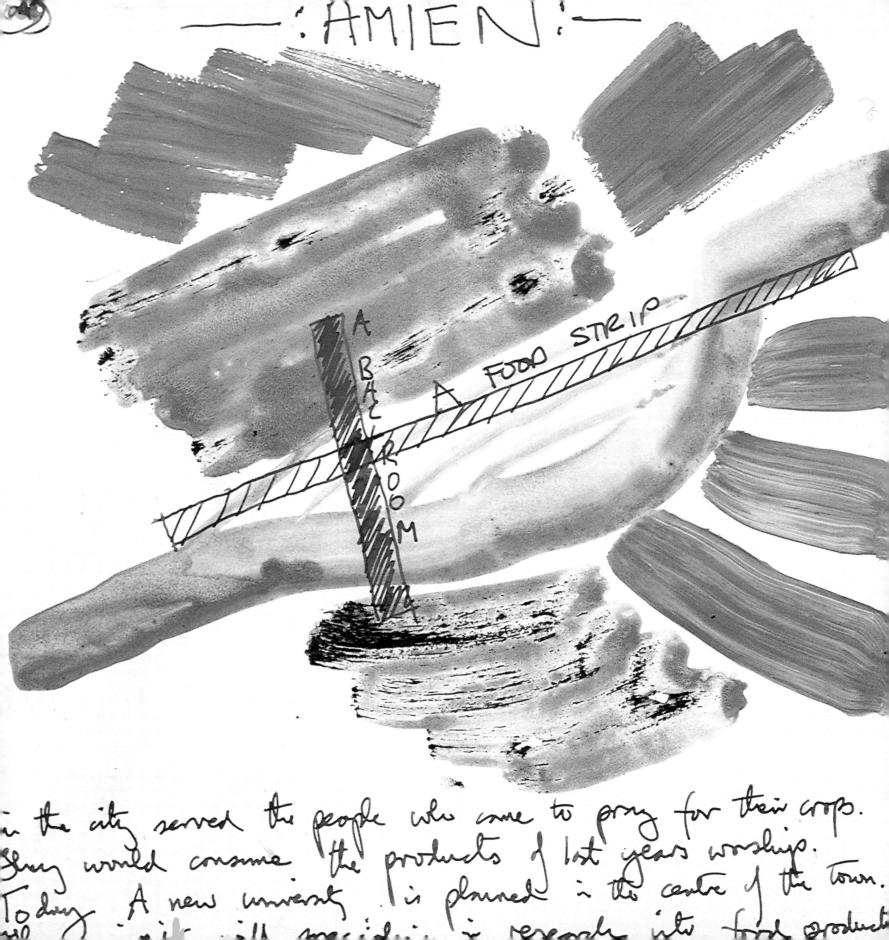

─ ─ :AMIEN:─ ─

A BALLROOM

A FOOD STRIP

...in the city served the people who come to pray for their crops.
They would consume the products of last years worships.
Today. A new university is planned in the centre of the town
...will specialise in research into food products

88

This project was a response to a consultation organized by the city of Amiens for ideas to maximize and co-ordinate its many advantages: a good transport infrastructure, a thriving university, historical sites, green areas and water. The project focuses on the 'active line' – an existing road which meanders from one side of the city to the other – and is given new life by the provision of a secret garden that intertwines with the road. Along its length three different sections provide a variety of activities: the glass section has a botanical hot house and laboratories; the water section an aquarium, swimming pool and water garden; and the open garden section has picnic areas, lawns and enclosed gardens. The western end terminates in a leisure activity area on the river with boating, pontoons and port-related activity. The eastern end culminates in the floating market which has historically been part of Amiens.

THE VISUAL CONNECTION
BLUE CORRIDORS of VISION

THE FOOD CATALYST ——————— A PLACE for ALL ——— A PLACE TO LEARN
A PLACE TO VISIT.

WATER PLANE

DISCONTINUOUS LAND PLANE

CONTAINER THAT VARIES —
A RESPONSE TO DAY & NIGHT / COLD & WARM /
WET & DRY.

A CLIMATIC MODERATOR TO PROMOTE GROWTH RESEARCH — A PLACE OF INTEREST.

REAL TIME SIGN

Permanent Blue SKY

BLUE BUSH
BLUE VEGETATION

BLUE
FRAME

ROAD

PLAN

SELECTED VIEWS.

89

Sketches and plan development of the 'active line'.

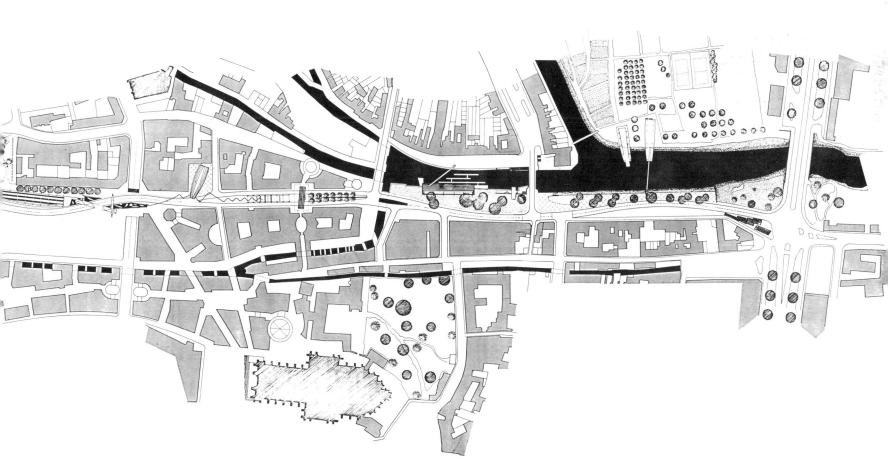

CLIENTS AND CONTEXTS

(Towards a conversation of architecture.)

What is required of the practice of architecture in the 1990s?
That the client should become the architect.

That the client will become involved directly in the practice of architecture, i.e. in the procedures of creative exploration and discovery that will lead to the making of beautiful buildings and urban places (for working / walking / playing / being entertained / meeting / arriving / departing / staying / eating and drinking etc.): places that meet known and unknown needs, that are flexible, that will make possible new forms of behaviour, new relations; places that will encourage conviviality and friendliness, discourage violence, eliminate the conditions that engender fear and loathing.

Such an architecture will be the product of conversation: civilized discourse (civilized being the proper word in this context). Discourse that in its ambit will include not only architects and clients, engineers and planners, politicians and users, but also artists and writers, aestheticians, historians, sociologists, psychologists, etc. At the heart of the discourse will be the conversation of those most closely involved in the commissioning and creating of projects: the clients, the architects and the artists.

(This would mean an extension into the public or corporate sphere of large scale developments of something of the relationship that often exists between an architect and a domestic client who is involved at every stage of the development of the project on the basis of known needs, desires and preferences.)

This differs greatly from what has been the case, what has happened so often in the past, and what is happening now. To take a typical scenario: a client (an individual developer / a city council / a government etc.) wants a building, commissions the architect, (conceived of as an individual genius or visionary), who projects the building as a personal statement, within the given constraints of the commission, and allowing for alteration to meet public opinion, changes of dedicated purpose, unforeseen budgetary restrictions etc. (The architect recognizes that such accommodations can be creative: creative compromise is the essence of effective architectural practice.) *(vide PERSONALITY / EXPRESSION / LANGUAGE)*

Modifications are largely determined by costs. The building is built. It becomes the subject of debate, conducted mainly in terms of the architect's recognizable idiosyncracies, and in the context of aesthetic givens and stylistics. (Compare this with Alsop's *NO STYLE / NO BEAUTY!*)

The magnitude and importance of the Marseille project has led Alsop to new considerations of context. Having entered the international superleague, his status as visionary architect confirmed, Alsop is perceived to have become a 'signature' architect. In fact Alsop's practise has been an active critique of that idea: collaboration has been crucial to him; he has no fixed ideas about the ultimate use of his buildings; he has resorted to techniques that deconstructively question what people mean when they describe what they 'need' or 'want'. (*vide BEHAVIOUR)* The proposals for Berlin, developed from projections initiated in creative collaboration with Bruce McLean, were more than an expression of new possibilities: at once utopian and provisional, they constituted a brilliant call for the new context.

The imaginative extension of architectural practice to incorporate the creativity of the client into its processes (aesthetic, critical, technical) at every moment of their development is threatened in two ways:

1 A consequence of the (comparatively) recent emergence of the international superstar auteur architect, who is commissioned to produce a visionary 'concept', has been that some clients would wish to alienate the architect from the realization of that concept. They go to the architect as someone who can produce interesting forms, be spectacular, solve particular problems, imagine new possibilities, but fail to recognize that a visionary may also be pragmatic and practical. The client buys the vision: the engineers and the contractors build within cost and political constraints in ways that merely compromise the vision. This is particularly likely in large-scale projects. Now what is absolutely important is that even when the architect must compromise within the opportunities that the commission provides, there should be no compromise at the level of value and vision. (Architectural vision is practical: its idealism instrumental.) The architect must therefore be involved at every stage in the total work.

 (A contradiction here: between the clients as their own architects; and the architect as controller? Not so. All too often the architect enters a project when much of the work has been done, and when compromises have already been made by the client, compromises not necessarily determined by the constraints of the situation. The client, that is to say, often makes architectural decisions without being his own architect, for he has neither the (architectural) vision, nor the (architectural) expertise. The client only truly becomes his own architect through creative conversation with the architect (and with the artist, the engineer, the writer, the user etc). Who will conduct/co-ordinate this complex discourse? – the architect.)

2 The development of a half-baked notion of 'community architecture' in which the client ('The community') states (through its representatives, elected or otherwise) what it wants. In this view the skill of the architect is to draw out of the community an articulation of its desires, and then be faithful to that articulation. What the community articulates must be right: only it can know what it wants. The architect becomes a mere facilitator. This is a simple-minded view of a complex process. Information gathered in whatever way from the client community must be useful: it is necessary but not sufficient. The problem is that if you ask people

(individually or collectively) what they want they tend to speak of what they already know, which is what they have already seen and experienced. It is the function of architecture, as of art and philosophy, to go beyond what is already known. Architecture must go beyond a reductive consensus. How then to produce an architecture responsive to the needs and desires of a client community in all their contradictory diversity? (The problem is ideological: i.e. at the heart of architecture.)

The architect, like the artist and the philosopher is useful, a kind of expert: architecture is a form of knowledge, a mode of imagining. The architect says to the client community: 'I have considered these problems for a great deal of time. It is not enough to ask me to facilitate what you want when you do not know what you might want: say what you want, and we will develop possibilities of realization that you haven't dreamed of. This way, together we shall imagine the future.' (The client becomes the architect.)

(Compare this with the contradictory outcomes of the BERLIN Potsdamer Platz / Leipziger Platz competition. The winning proposals, conforming to the civic (community) client's preconceptions, do not go beyond the known: the site envisaged as continuous with the city in scale and format; squares and streets and alleyways etc. It is a recapitulation of the past. In this case, it was the corporate clients for the individual buildings whose vision called for something else, something more adventurous, something more imaginative. (It could have been the other way round.) In any case, it was a perfect example of the need for a new context in which the clients might become the architects of their own projects. In Berlin the city authorities (=civic client) acted in the negative way in which planning departments tend to work in Britain: as an agency of control, maintaining a 'watching brief' on the constraints of law and of political expedience. Nothing wrong with such a role: let such agencies protect the known. But they are not much good with proposals for the unknown, the realizations of dreams.)

The new context of architecture is a context of responsibilities: responsibilities to the client; responsibilities to the people who live in, work in, walk through and past the buildings and spaces we jointly create; responsibilities to those who will need or wish to adapt those buildings to new and unforeseen purposes. Perhaps we should reverse Yeats's dictum: In responsibilities dreams begin.

Alsop: 'It sounds as if I am making more work for architects: and I am.'

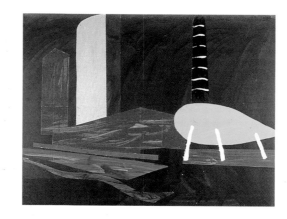

BERLIN
Potsdamer Platz
Leipziger Platz

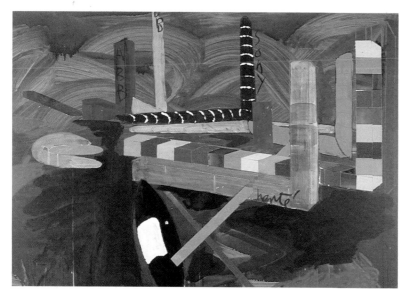

Paintings by Alsop and Bruce
McLean executed at McLean's
Spanish studio. All of the
original works were submitted
to the Berlin authorities as part
of the competition proposal.

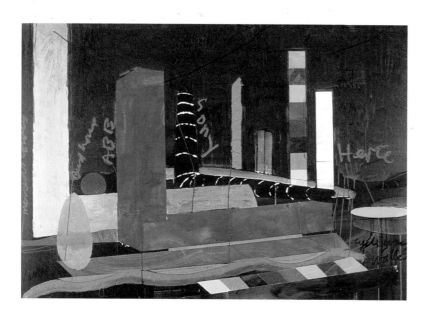

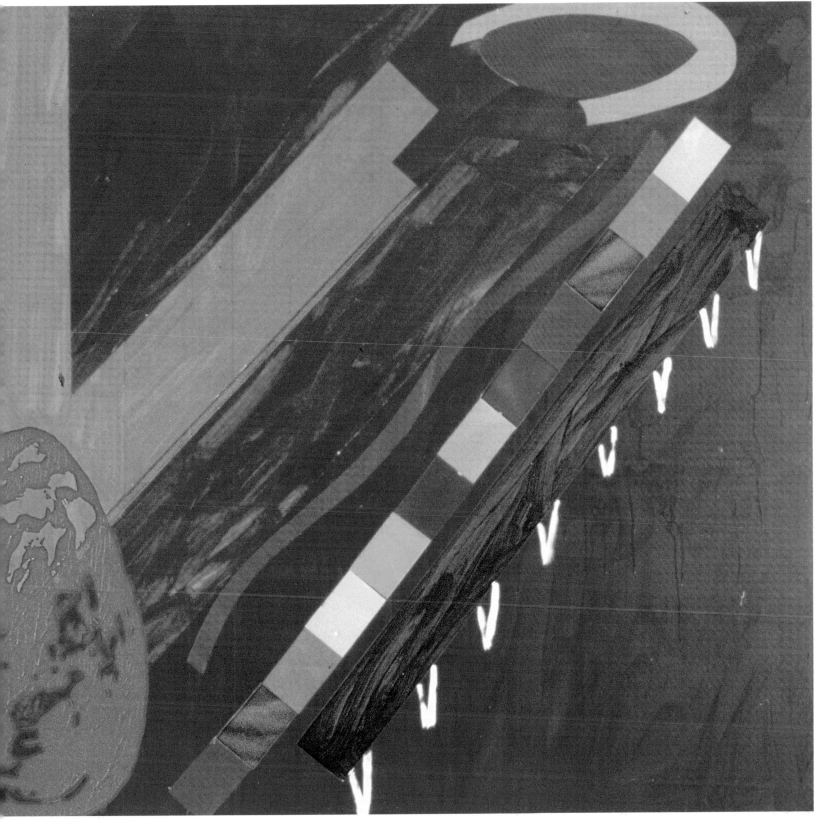

96

The area of Potsdamer Platz lies beyond common urban planning imagination. In this unpremiated competition scheme it is developed within a location of existing contrasts. Obstructed from change during the past decades by ideological and physical violence, this place is viewed as the focus of potentially explosive development. The proposal extends contextually the concept of the city of objects which defines the Kulturforum and extends this theory of randomly placed buildings with a series of streets as objects. An imaginary line across the Leipziger Platz separates this cityscape from the traditional Berlin City structure. East of this line the new buildings continue the traditional structure. West of it, the new Berlin City develops. Different uses are given to each of three principal levels. A network of horizontal and vertical connections unite the levels, allowing movement between servicing and car parking at level −1 to level ±0 which forms a randomly arranged city space with defined areas of activity. The +1 level forms an elevated common ground level. The 'city in the park' allows a deliberate ambiguity between urban space and open park. Activities take place either inside or outside the buildings, depending on the time of day and year. In winter, the buildings become the 'streets', offering protection from the cold east wind and providing an environment of passages for walking, shopping, leisure and entertainment. In summer the parkland forms an alternative streetscape.

Sketches showing the development of buildings, forms and structures.

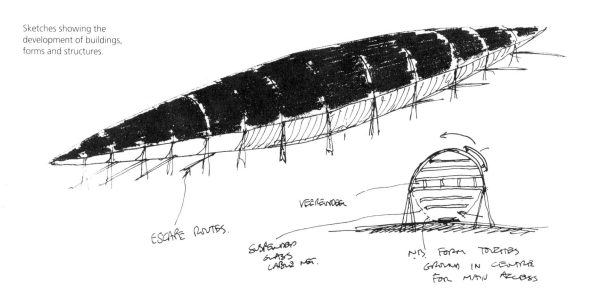

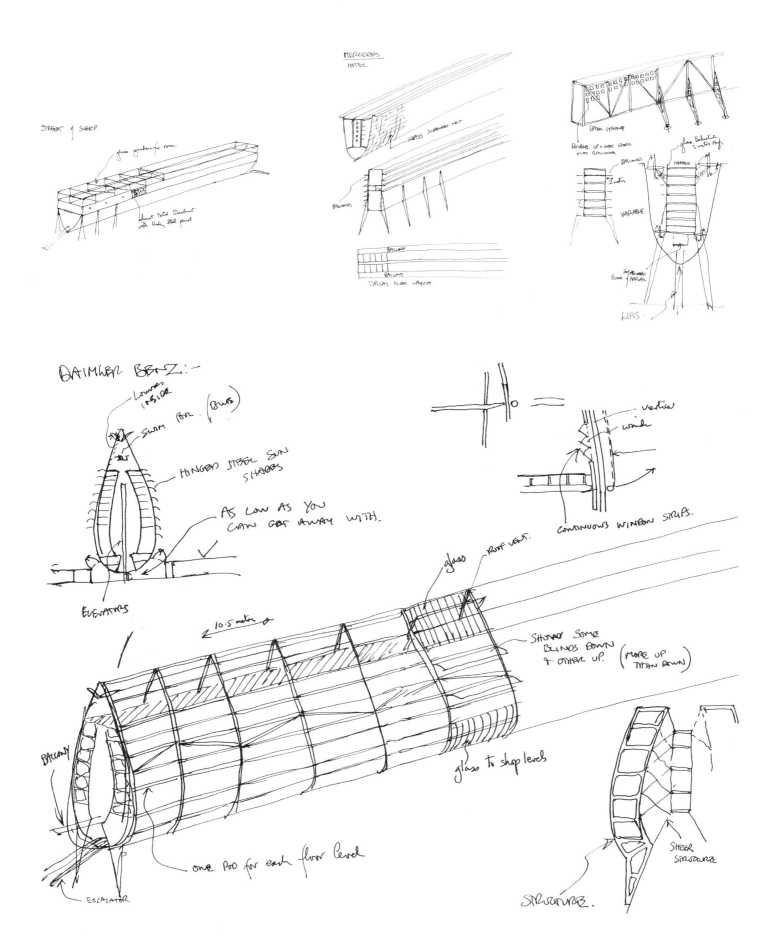

STREET OF SLEEP.

glass garden for room.

behind tinted blackout
with sliding steel panels

GLASS SUSPENDED NET.

BALCONIES

BALCONY

BALCONY

TYPICAL FLOOR LAYOUT

BASIC STRUCTURE

DOUBLE UP + OVER ROADS
INTO BALCONIES

glass Balustrade
3 metres high

BALCONIES

TERRACE

2 metres

VARIABLE

SUSPENDED
FLOOR + ATRIUM

LIFTS.

DAIMLER BENZ:-

LOUVRES
INSIDE

SWIM POOL (BLUE)

HINGED STEEL SUN
SHADES

AS LOW AS YOU
CAN GET AWAY WITH.

ELEVATORS

vertical

winter

CONTINUOUS WINDOW STRIPS.

glass ROOF VENT.

10.5 metres Ø

SHOW SOME
BLINDS DOWN
+ OTHER UP. (MORE UP
THAN DOWN)

BALCONY

glass to shop levels

one pod for each floor level

ESCALATOR

SHEER
STRUCTURE

STRUCTURE.

SONY

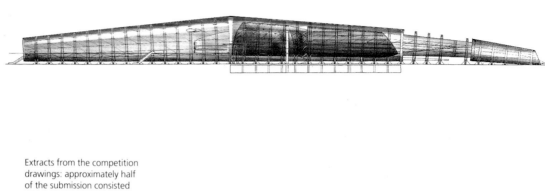

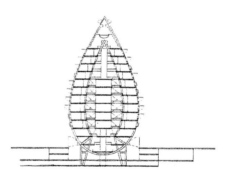

Extracts from the competition drawings: approximately half of the submission consisted of paintings, the remainder comprised architectural drawings. The drawings, like the paintings, were fully coloured.

DAIMLER BENZ

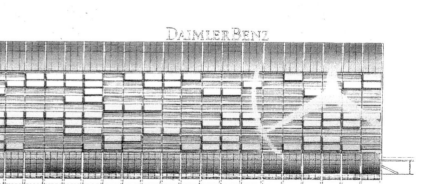

BÜROS + HOTEL

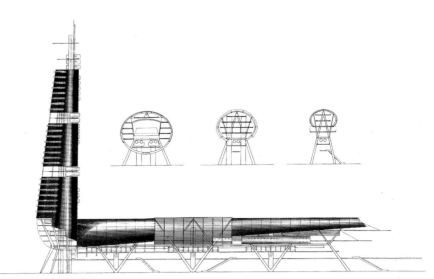

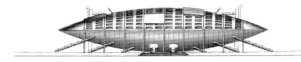

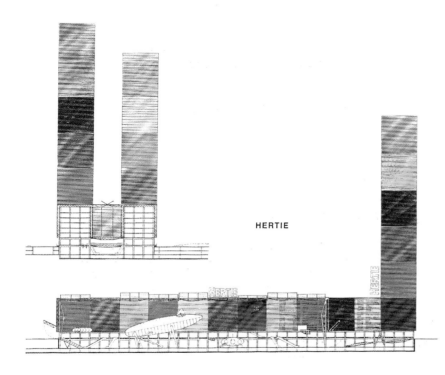

HERTIE

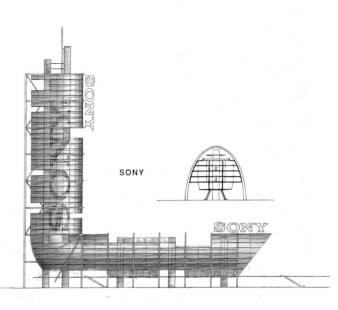

SONY

100 CRBARGE PLATZ RISCBS FOR THE TWO HORIZANTAR ACTIVITY

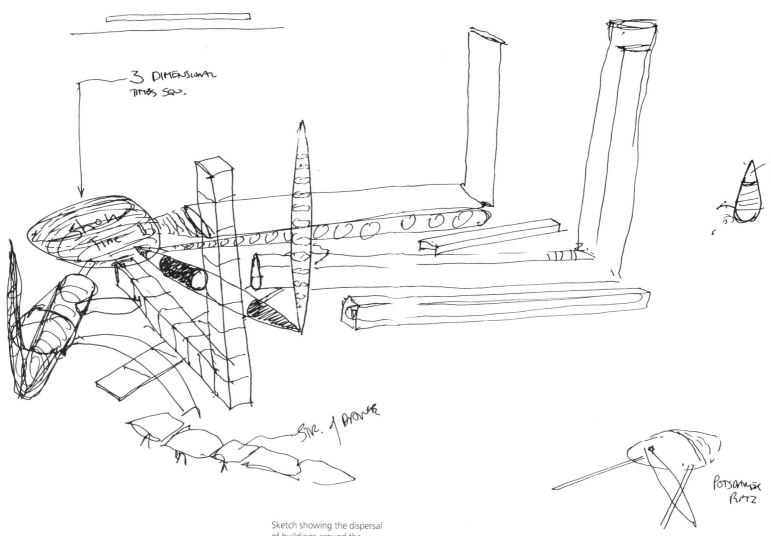

3 DIMENSIONAL TIMBS SQU.

STR. J BROWER

POTSDAMER PLATZ

Sketch showing the dispersal of buildings around the Potsdamer Platz transport interchange.

Competition plan at an elevated level cutting through the towers.

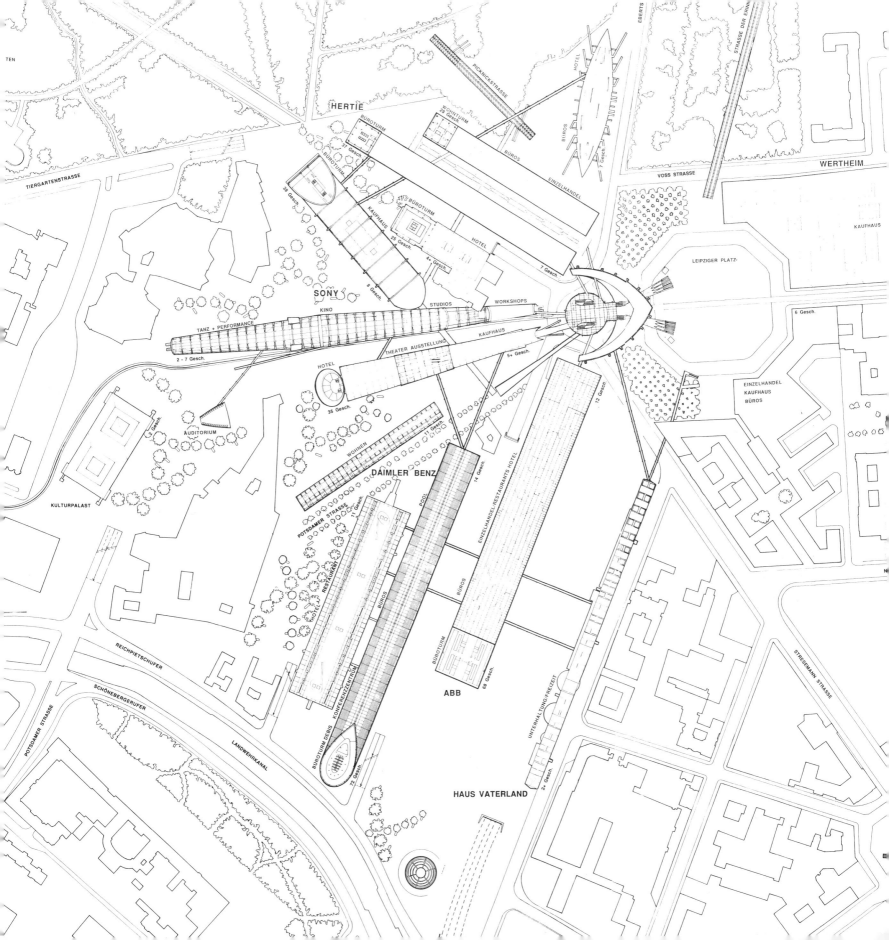

102

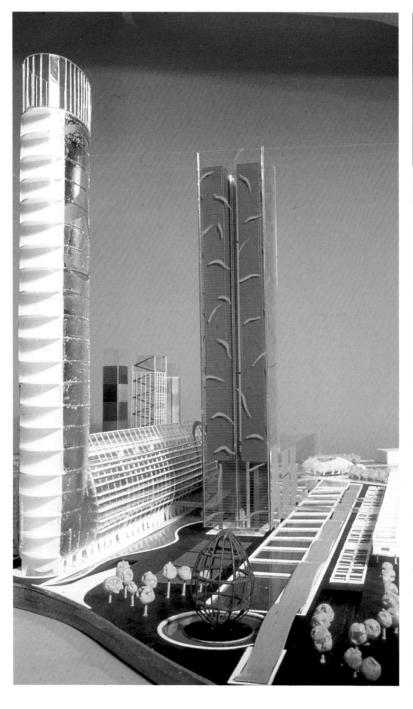

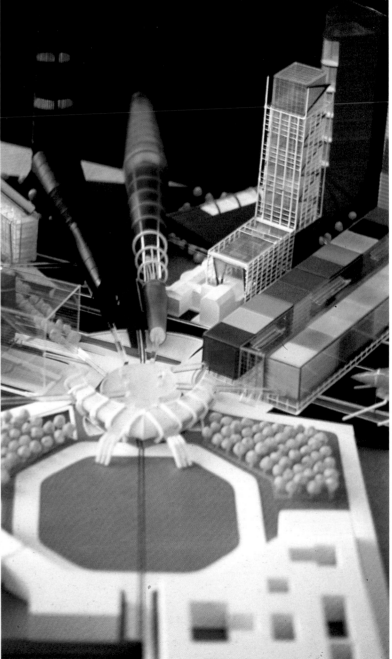

far left: An oviform aviary is located in front of two office towers, terminating a blue water strip, roller skating waves and flower gardens behind.

left: View over Leipziger and Potsdamer Platze.

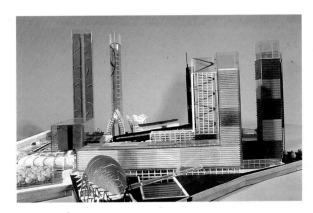

Views of the competition model. This, like the paintings and drawings, was fully coloured to reflect the importance of colour as a distinct element of the proposal. (The brief asked for a white model.)

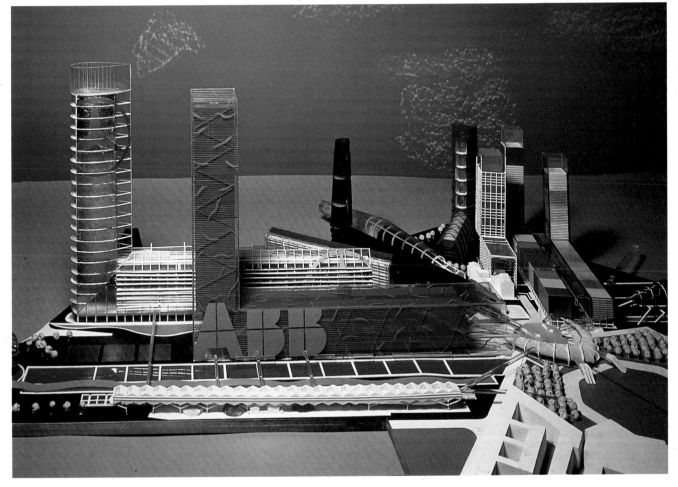

SINGAPORE
Telecom Tower

This glass-skinned communications tower takes its place within the Singapore city skyline and will be clearly visible from great distances. Located in the context of Canning Park, the tower is considered as a positive intervention. Free of a podium or other interruptions the tower appears to continue beneath the surface of the hill on which it stands. All elements of the basement are concealed below ground level allowing the tower's apparent footprint to be kept to a minimum. The existing grass plateau, in itself a delightful place to be, is largely maintained for public use. At the point of public arrival the base of the tower is organized as a clear floor space with direct access to the public lifts that rise to a high-level viewing platform. As visitors enter through the glass skin they can look up to see the top of the tower within the enclosure; an extraordinary spatial experience. The tower's arrangement of pods and open deck floors allows the flexible location of its various pieces of communications equipment. Essentially, it is seen as a weather-tight armature which can be dressed or re-dressed with technology as future requirements dictate.

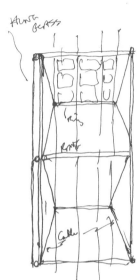

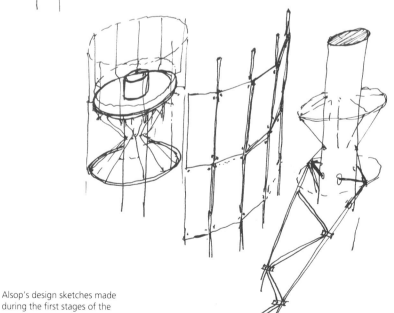

Alsop's design sketches made during the first stages of the project.

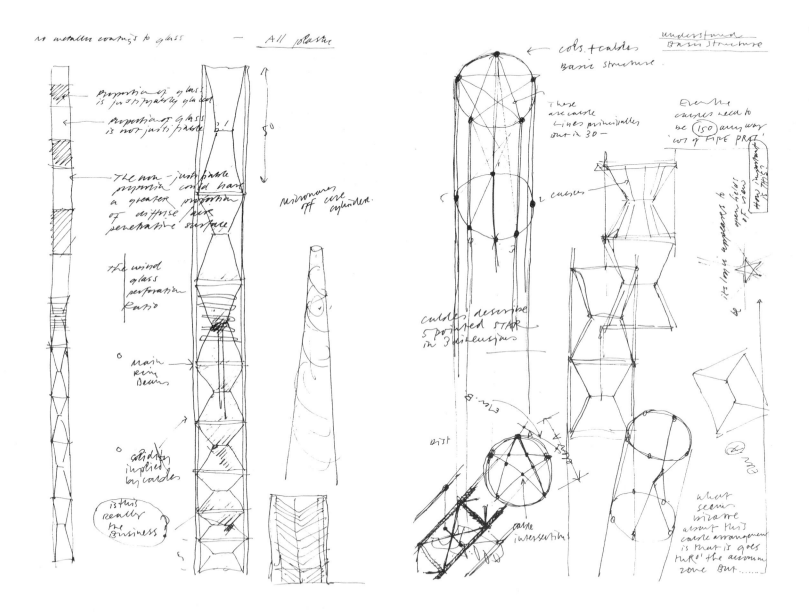

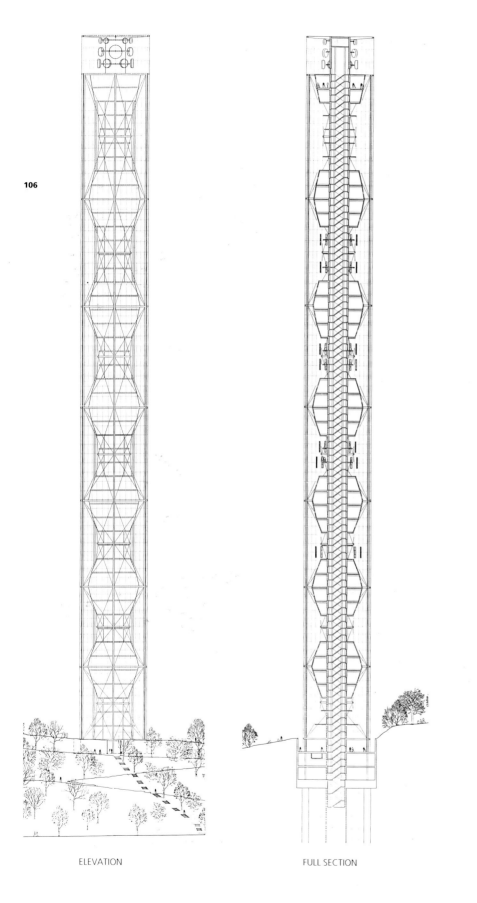

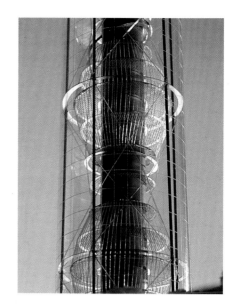

Model detail.

ELEVATION

FULL SECTION

LOCATION PLAN

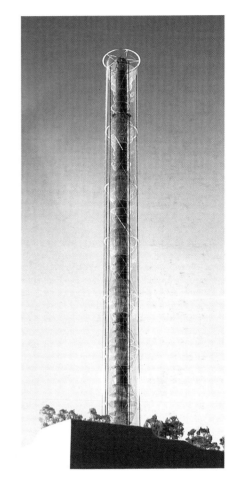

Competition presentation
image.

Plans at various levels of the
tower.

COLOGNE
Media Park

This scheme proposes a 'media park' that can be built and occupied incrementally as it grows to form a 750 metre linear strip. The complex consists of four basic compositional elements: the park itself, a large trench, a supportive mid-section and a high-level inhabited 'beam'. The project realizes its didactic potential by allowing the general public to observe, and wherever possible, to participate in the world that surrounds the 'media' in its broadest sense. At one end of the park proper is a hotel for businessmen and their families, providing them with a more intimate 'home' environment in the form of spacious serviced apartments. This overlooks the actual park which opens out to interact with the Electronic Park. This is specifically for the general public and is a media version of a theme park. It allows the people of Cologne to engage in experiential delights, playing and experimenting with machines and information. A swimming pool, which runs both inside and outside, is very long and only 2.75 metres wide, designed specifically for swimming as opposed to idle splashing about. The office accommodation is supported on stilts above a public arcade of shops, galleries, training areas and technical facilities. On the far side of the stilts, tennis courts are situated on the roof of a television studio and manufacturing space. Access is restricted to the offices themselves although they are designed to be clearly visible to the public from below. The south side of the office section is devoted to a tomato farm in response to Will Alsop's heartfelt belief that everyone who works in an office should be able to eat fresh tomatoes for their lunch.

A question of spirit

These buildings are not timeless in their intent. They are not classics. They are designed to be corrupted.

Extracts from Alsop's early development sketches showing the elevated office 'beam' and supporting stilt structure.

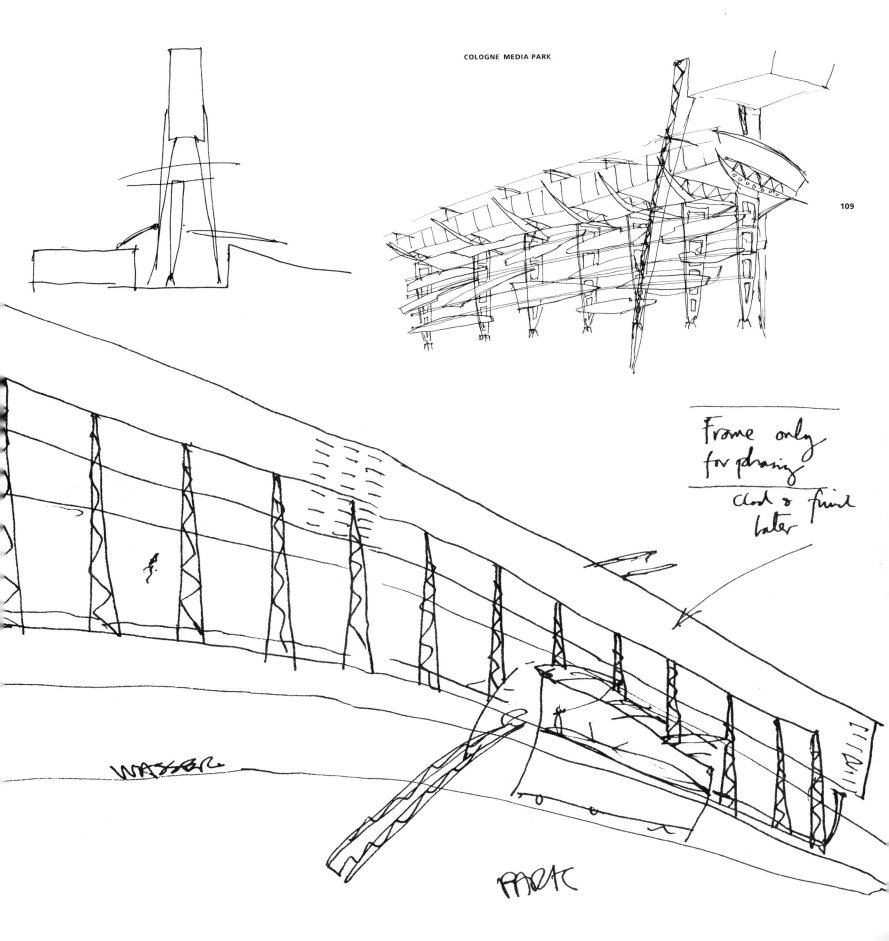

109

Frame only
for phasing

Clad & finish
later

WASSER

PARK

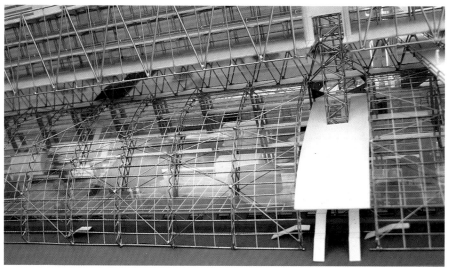

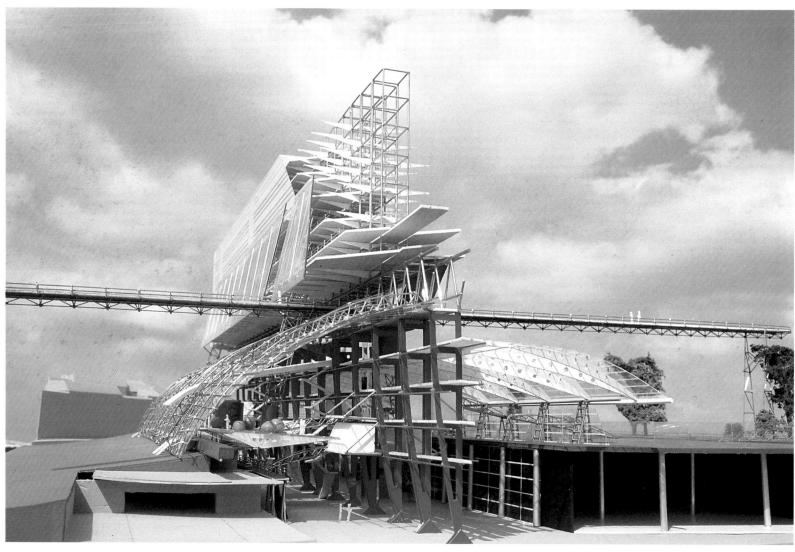

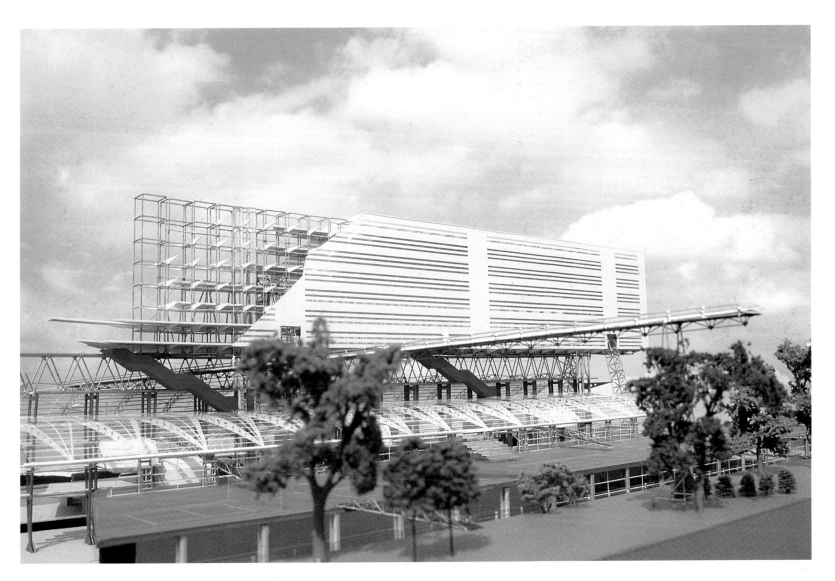

Views of the competition model. Built at scale of 1:200, it showed only the first 200 metres of what would become a 750 metre linear strip, and was cut away to reveal the structure.

**TEACHING /
LEARNING**

Alsop: 'If you learn a particular skill you feel obliged to use it: skill-based teaching (training) inhibits creative thinking. (Skills are necessary to the creative process, but they will be learned when they are needed, and then they may lead to further discovery, and form the basis of another level of creativity.)'

Teaching (in art and architecture) should aim to free the student from preconceptions about what is or is not possible, not encourage a knowingness. Alsop's teaching has always been concerned with maintaining an openness to possibilities, to what may develop out of experiment and the free play of the imagination. (This is not so different from his practice.)

On his first day at the Architectural Association, Alsop was told by the principal, John Lloyd, that the whole point of the place was that you didn't have to think about becoming an architect. At St Martin's School of Art a similar philosophy prevailed: you might become a sculptor, or you might not.

(Discipline is essential to any process of learning. Alsop's teaching is always 'project-based'; it demands a high level of creative engagement with an idea or set of ideas which might lead anywhere. He is not concerned with the application of skills to solve 'problems', of energies to accomplish 'tasks', so much as with open-ended processes of thought and imagination, leading to the discovery of the unpremeditated, the arrival at the unpredicted.)

At Bremen Academy of Art and Music Alsop teaches a postgraduate course leading to no 'qualification'. Students are involved in purely imaginative work, 'probing the limits of architecture', questioning their attitudes, asking what architecture might be, in actual projects in the city, projects to do with the city itself as

an active environment (ways of moving through; use and modification of open spaces; landscape). Not buildings. There is a progression: from investigative experiment to practical use of the imagination in real work in the city, to interaction with the city departments, in which they respond to the analyses and proposals the students present. (The students are paid by the city for their work.) Those responsible for planning, building, landscaping and so on – those who make the decisions in the real city – learn from the students and from the visitors to the Academy, while the students and teachers on the course are professing and practising in conditions of actuality. Actual because real architecture operates at the heart of the political process, and embodies ethical and political values.

A real education (and a real architectural education) would encourage civic pride and dignity as components of a general ethic of social life. A purely instrumental approach (problem solving/ non-speculative) discourages imaginative definition of the possibilities of life.

(The beginnings of a model for a new academy? Informed by a vision of the architect and artist as a worker within the social and political totality; actively practical at the heart of the community. Not merely as maker of objects or designer of buildings, but as the proposer of new forms of behaviour, the questioner of existing realities. Compare this with Cedric Price or Joseph Beuys.)

Alsop: 'Once you understand you have nothing to teach, then you can teach. I've learnt least from experts. They are there to be consulted, their expertise is a resource. The fact that they know what they know means you can be free to learn what they don't know, and what can't be learned from them.'

Alsop's studio space at the
Bremen Hochschüle für
Künste.

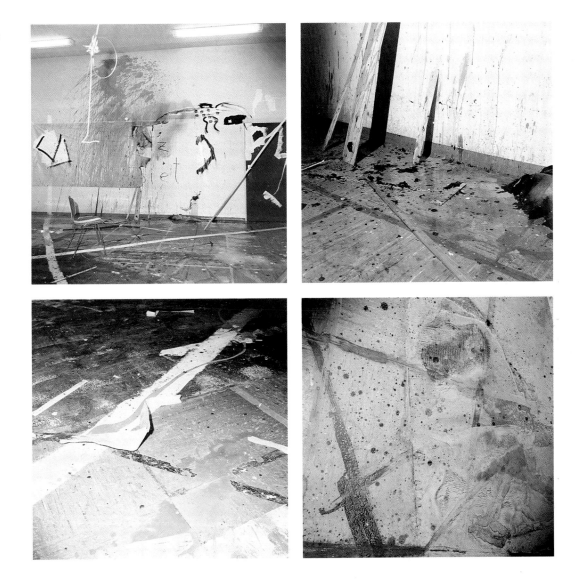

BIBLIOGRAPHY

Hérouville Saint-Clair
'Shop of the New', Kester Rattenbury, *Building Design*, 18 January 1991

Cardiff Bay Visitors' Centre
The Sunday Times, Hugh Pearman, 18 November 1990
Architects' Journal, 24 April 1990

Cardiff Bay Barrage
'Cardiff Crossing', Paul Finch, *Building Design*, 8 November 1991

The British Pavilion, Seville Exposition 1992
'Seville '92, Proposal for the English Pavilion', Lucia Bisi, *L'Arca*, 1990
Design Week, Linda Relf-Knight, 3 March 1989
Architects' Journal, 'Two for Seville', 22 March and 5 April 1989
Building Design, Paul Finch, 31 March 1989

Hotel du Département, Marseille
S&D (Japan), February 1992
'Mood Indigo In Marseille', Marcus Binney, *The European Times*, 11 March 1992
Estate Gazette, 7 March 1992
The Daily Telegraph, Kenneth Powell, 5 September 1990
'Marseille, Marseille', John Welsh, *Building Design*, 20 July 1990

Potsdamer, Leipziger Platz, Berlin
'New Visions for the Killing Zone', Deyan Sudjic, *The Guardian*, 28 October 1991
'Willkommen in Berlin', Amanda Baillieu, *Building Design*, 11 October 1991

William Alsop Profile
'The Brush Works', Deyan Sudjic, *The Guardian*, 20 February 1992
'Colour Him a Non-specialist', Marcus Binney, *The Times*, 6 January 1992

Practice Profile
'A Will to Succeed', Hugh Pearman, *The Sunday Times*, 15 December 1991

AWARDS

1990	Leeds Corn Exchange	Design Week Award
1990	Leeds Corn Exchange	Leeds Award for Architecture
1990	Leeds Corn Exchange	Ironbridge Award
1991	Leeds Corn Exchange	White Rose Award
1991	Cardiff Bay Visitors' Centre	RIBA Regional Award for Architecture – *Sunday Times* Royal Fine Art Commission
1992	Cardiff Bay Visitors' Centre	RIBA National Award for Architecture

COMPETITIONS

1971	Centre Pompidou – 2nd prize
1982	Westminster Pier – 1st prize
1986	City of Hamburg, Shipfish Office Bridge – special prize
1987	City of Cologne, Cologne Media Park – special prize
1988	Logistic Centre, Hamburg – 1st prize
1990	Hotel du Département, Marseille – 1st prize
1990	UK Pavilion, Seville Exposition 1992 – 2nd prize
1991	Potsdamer / Leipziger Platz – 4th prize

CURRICULA VITAE

William Alsop AADip SADG RIBA FRSA
Born: Northampton, England 1947

Qualifications
Architectural Association Diploma
Member of the Royal Institute of British Architects
Société Architectes Diplômes par le Gouvernement
Fellow of the Royal Society of Arts
Bernard Webb Scholar, Rome
William van Allen Medal for Architecture, New York
Professor, Bremen Academy for Art and Music

Academic appointments
Unit Master, Architectural Association
Visiting Professor, Ball State University, Indiana
Visiting Professor, Royal Melbourne Institute of Technology
Visiting Professor, New South Wales Institute of Technology
Visiting Professor, San Fransisco Institute of Art
The Davis Professor, Tulane University, New Orleans
Tutor in Sculpture, St Martin's School of Art

Previous architectural appointments
1971 Maxwell Fry
1973–77 Cedric Price
1977–79 Roderick Ham

Jan Störmer
Born: Berlin, Germany 1942

Qualifications
Dipl. Ing Architekt

Academic training
1960–62 Ingenieruschule in Bremen
1964–65 Planungstätigkeit in Bremen
1965–69 Studium Hochschule für Bilende Künste, Hamburg,
 Diplom, Dipl-Ing

Previous architectural appointments
1969 Gründung eines Planungsbüros
1970 Partner der Planungsgruppe me di um
1977 Partner von me di um-hw, Architekten und Ingenieure

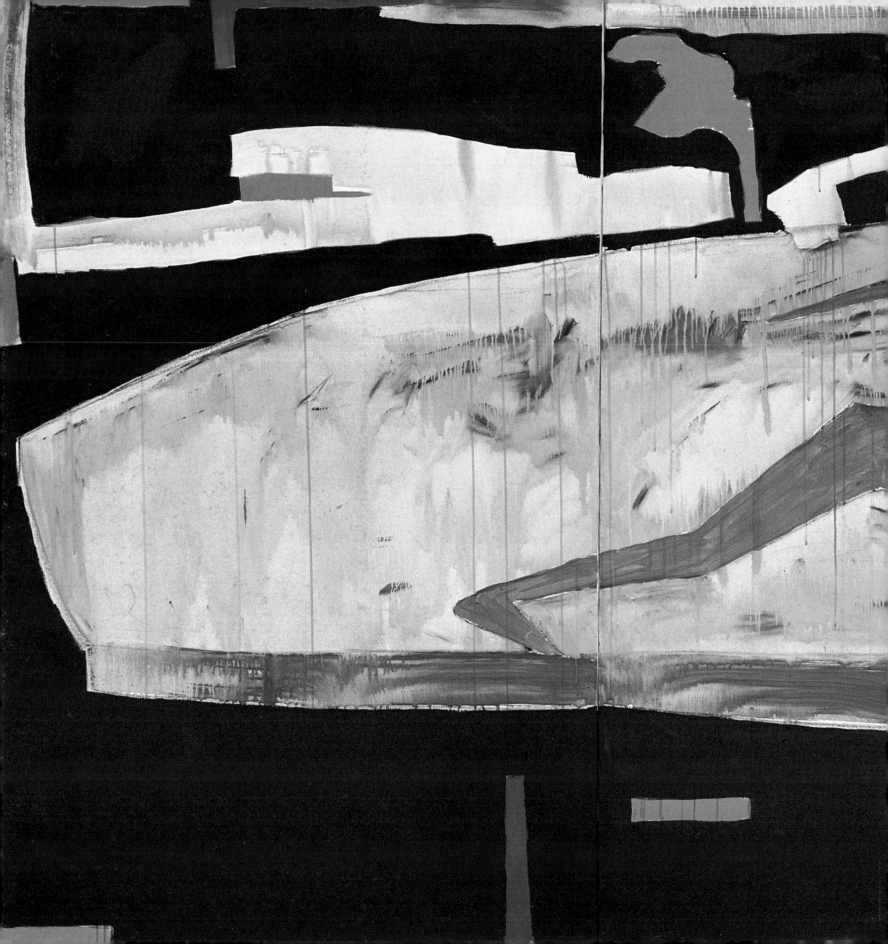

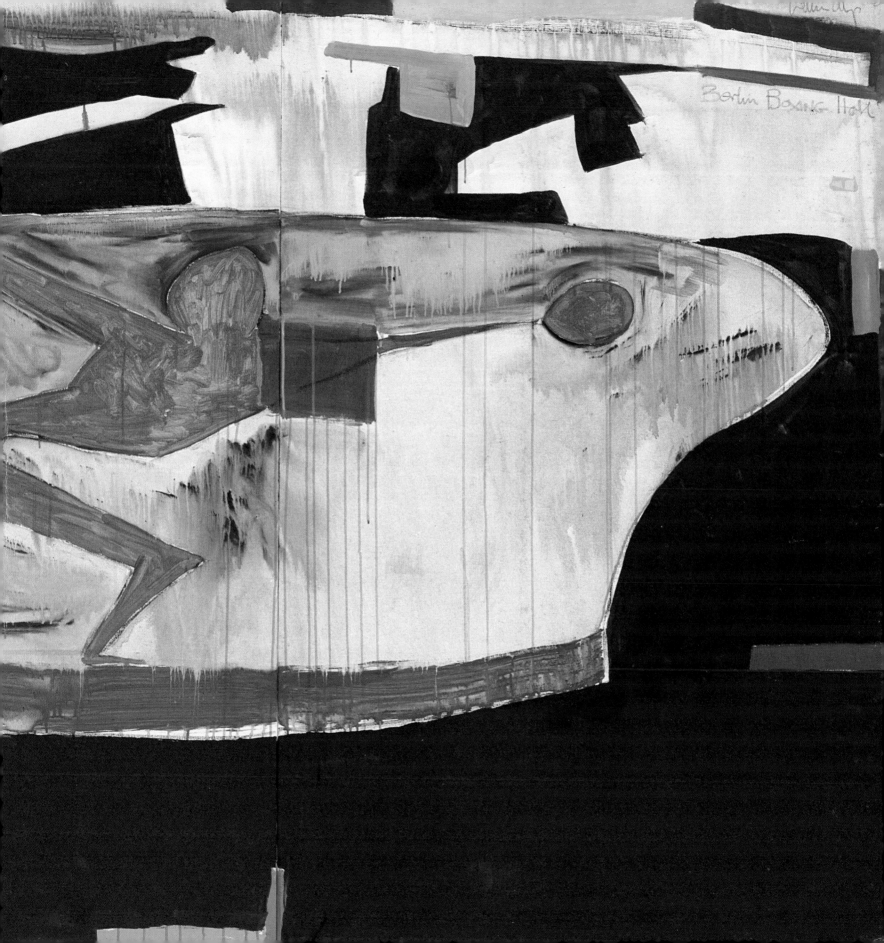

CREDITS

HÉROUVILLE ST-CLAIR SHOPPING CENTRE, LA TOUR EUROPÉENE
Location:
Hérouville St-Clair, France
Client:
The City of Hérouville St-Clair
Date:
1990
Value:
£6 million
Project architect:
Andrea Reason
Structural engineer:
Ove Arup & Partners

CARDIFF BAY VISITORS' CENTRE
Location:
Cardiff Bay Docklands, UK
Client:
Cardiff Bay Development Corporation
Date:
Awarded March 1990
Start on site:
June 1990
Completion:
October 1990
Value:
£750,000
Project architect:
Pankaj Pandya
Structural engineer:
Atelier 1
Quantity surveyor:
Roger Farrow
Service engineer:
Rybka, Smith, Ginsler & Battle Ltd

CANARY WHARF EASTERN ACCESS CONTROL BUILDING AND LIFTING BRIDGES
Location:
London, UK
Client:
London Docklands Development Corporation
Date:
Awarded 1988
Start on site:
January 1990
Completion:
December 1990
Value:
£4 million
Project architect:
Peter Clash
Structural engineer:
Mott MacDonald
Quantity surveyor:
Baker Wilkins Smith

PORT DE LA LUNE, BORDEAUX, LA CATHÉDRALE ENGLONTIE – THE GARONNE ACTIVATOR
Location:
The River Garonne, France
Client:
The City of Bordeaux
Date:
November 1990
Project architect:
Jonathan Adams
Structural engineer:
Ove Arup & Partners

CARDIFF BAY BARRAGE
Location:
Cardiff Bay Docklands, UK
Client:
Cardiff Bay Development Corporation
Date:
Awarded October 1989
Value:
£100 million
Project architect:
Peter Clash
Engineer:
Sir Alexander Gibb & Partners Ltd
Quantity surveyor:
Bradford Bowen & Partners

THE BRITISH PAVILION, SEVILLE EXPOSITION 1992
Location:
Seville, Spain
Client:
The Department of Trade and Industry
Date:
January 1990
Value:
£8 million
Project architect:
H. Jaedicke
Structural engineer:
Ove Arup & Partners
Quantity surveyor:
Hanscombs Ltd

MARSEILLE HOTEL DU DÉPARTEMENT
Location:
Marseille, France
Client:
Département des Bouches du Rhone
Date:
Awarded August 1990
Start on site:
November 1991
Completion:
January 1994

Value:
£85 million
Project architect:
Stephen Pimbley
Structural engineer:
Ove Arup & Partners, OTH Mediterranée
Quantity surveyor:
Hanscomb Ltd

HAMBURG FERRY TERMINAL
Location:
Fischerei Hafen, Hamburg, Germany
Client:
DFDS Danish Seaways, Reederei B. Rickmers, JF Müller & Sohn AG
Date:
Awarded 1988
Start on site:
August 1990
Completion:
June 1991
Value:
£10.7 million
Project architect:
H. Jaedicke
Structural engineers:
Ove Arup & Partners, Sellhorn Jng. Ges MbH
Mechanical engineer:
Ove Arup & Partners

AMIENS URBAN INTERVENTIONS
Location:
Amiens, France
Client:
The City of Amiens
Date:
May 1990
Value:
£30 million
Project architect:
Emmanuelle Poggi

BERLIN POTSDAMER LEIPZIGER PLATZ
Location:
Berlin city centre, Germany
Client:
The City of Berlin
Date:
September 1991
Value:
£120 million
Project architect:
Jonathan Adams
Structural engineer:
Ove Arup & Partners
Collaborating artist:
Bruce McLean

SINGAPORE TELECOM TOWER
Location:
Canning Park, Singapore
Client:
Singapore Telecom
Date:
September 1992
Value:
£30 million
Project architect:
Peter Clash
Structural engineer:
Ove Arup & Partners
Quantity surveyor:
Roger Farrow

COLOGNE MEDIA PARK
Location:
Cologne, Germany
Client:
The City of Cologne
Date:
1986
Value:
£25 million
Project architect:
Tanja Riccious

previous page: William Alsop's study painting for the Berlin Boxing Hall, 1992